The Decorated Letter

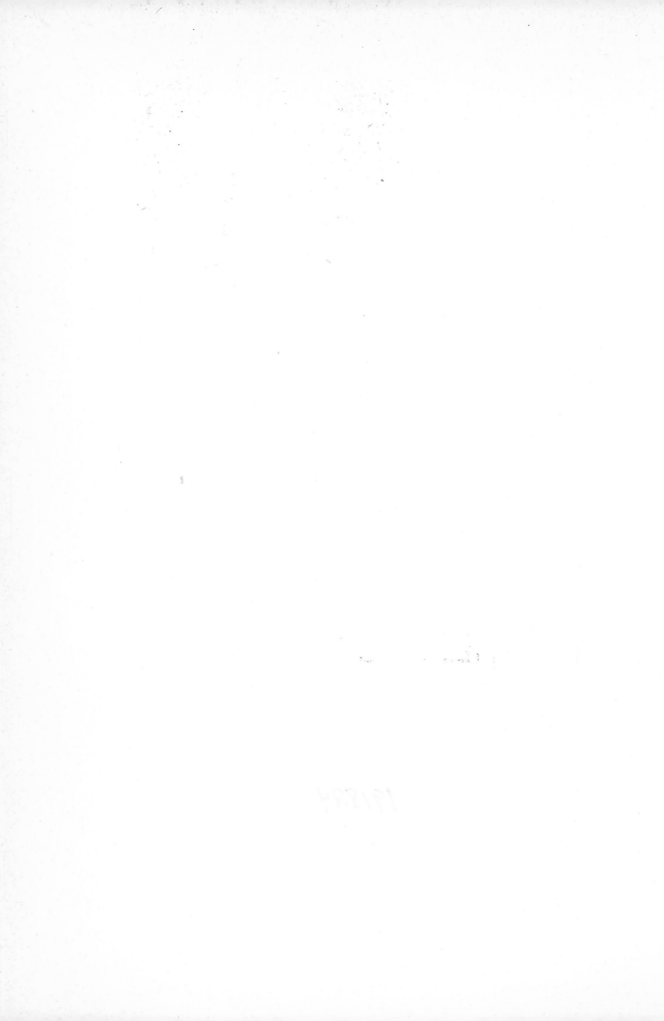

THE
DECORATED
LETTER

J.J.G. ALEXANDER

GEORGE BRAZILLER / New York

TO MEYER SCHAPIRO

Published in 1978.
All rights reserved.
For information address the publisher:
George Braziller, Inc., One Park Avenue, New York, New York 10016

Library of Congress Cataloging in Publication Data
Alexander, Jonathan James Graham
 The decorated letter.
 Bibliography: p.31
 1. Initials. 2. Decoration and ornament — Themes,
motives. 3. Illumination of books and manuscripts.
I. Title.
ND3335.A43 745.6'7 78–6487
ISBN: 0–8076–0894–7
ISBN: 0–8076–0895–5 pbk.

First Printing

Printed by Imprimeries Réunies in Switzerland
Designed by Diane Kosowski

Contents

Acknowledgments

The author and publishers would like to express their sincere thanks to the following institutions and individuals who kindly provided materials and granted permission to reproduce them in this volume.

Color Plates
ARRAS, Bibliothèque Municipale, Plate 22 (Photo: Studio Malaisy).
BALTIMORE, Walters Art Gallery, Plate 33.
BAMBERG, Staatsbibliothek Bamberg, Plate 13.
BERGAMO, Biblioteca Civica, Plate 36 (Photo: Wells Foto).
BERLIN, Bildarchiv Preussischer Kulturbesitz, Plate 37.
BRUSSELS, Copyright Bibliothèque Royale Albert Ier, Plate 40.
CHANTILLY, Musée Condé, Plate 25 (Photo: Lauros-Giraudon).
DUBLIN, The Board of Trinity College, Plate 2 (Photo: The Green Studio Ltd.).
HEIDELBERG, Universitätsbibliothek Heidelberg, Plate 11.
LONDON, Reproduced by permission of the British Library Board, Plates 1, 5, 15, 16, 26, 28, 29, 38.
LONDON, The Lambeth Palace Library, Plate 18.
MADRID, Biblioteca Nacional, Plate 27.
MANCHESTER, The John Rylands University Library, Plate 12.
MUNICH, Bayerische Staatsbibliothek Munchen, Plates 10, 20.
NEW YORK, The New York Public Library, Plate 31, Courtesy of the Spencer Collection.
NEW YORK, The Pierpont Morgan Library, Plates 8, 21, 30.
OXFORD, The Bodleian Library, Plate 17.
PARIS, Bibliothèque Nationale, Plates 3, 4, 6, 7, 9, 23, 24, 32, 34.
SIENA, Duomo, Biblioteca Piccolomini, Plate 39.
VIENNA, Österreichische Nationalbibliothek, Plate 35.
WINCHESTER, Courtesy of the Dean and Chapter of Winchester, Plate 19.
WOLFENBÜTTEL, Herzog August Bibliothek, Plate 14.

Black-and-White Figures
ALBI, Bibliothèque Municipale Rochegude, Figure XXIV.
AMIENS, Bibliothèque Municipale, Figures V, VI.
AVRANCHES, Bibliothèque Municipale, Figure IX (Photo: François Avril).
BRUSSELS, Bibliothèque Royale Albert Ier, Figure XXIX.
CAMBRAI, Bibliothèque de Cambrai, Figures IV, XV.
CAMBRIDGE, The Fitzwilliam Museum, Figure XXV.
DIJON, Bibliothèque Municipale, Figures XII, XIII, XIV.
DUBLIN, Courtesy of the Officers of the Royal Irish Academy, Figure II (Photo: The Green Studio Ltd.).
HILDESHEIM, St. Godehard's Church, Figure XXVIII (Photo: The Warburg Institute, The University of London).
LONDON, Reproduced by permission of the British Library Board, Figures III, XVI, XXVI.
LONDON, by Courtesy of the Victoria and Albert Museum, Figure XXIII (Photo: The Courtauld Institute, The University of London).
OXFORD, The Bodleian Library, Figures VIII, XI, XVII, XIX, XXX.
OXFORD, The Warden and Fellows of Merton College, Figure XXI (Photo: The Bodleian Library).
PARIS, Bibliothèque de l'Arsenal, Figures XVIII, XX (Photos: R. Lalance).
PARIS, Bibliothèque Nationale, Figures VII, XXVII.
ROME, Biblioteca Apostolica Vaticana, Figure I.
ROUEN, Bibliothèque Municipale, Figure X (Photo: Photo Ellebe).
VIENNA, Österreichische Nationalbibliothek, Figure XXII.

Introduction

This book is an anthology of decorated letters to be found in European manuscripts from the fourth to the fifteenth century. At the beginning of this period, the codex form of book with which we are still familiar was becoming standard, that is, a book consisting of bound, folded sheets generally of animal skin. As early as the second century A.D. it had begun to make obsolete the papyrus roll of the Ancient World. All the processes involved in the production of the codex—the preparation of the skin, the writing ("manuscript" meaning "hand written"), the decoration, and illustration — were done by hand. By the end of this period, however, the mechanical art of printing texts with moveable type had been invented, the first complete book so produced being the forty-two-line Bible printed by Gutenberg at Mainz in 1456. The printers were also able to use wood blocks for the mechanical reproduction of illustrations and decorations in their books.

The decorated letters chosen in this selection must, therefore, be seen in the context of the period during which they were produced and of the purpose for which they were designed. Carl Nordenfalk has made a masterly study of the earliest initials, that is in our context, letters which, emphasized by decoration of some form, generally introduced a textual division in a book or a heading.[1] He has observed that there are two vital factors which gave rise to the development of the decorated letter. The first was the change over in attitude to the text. In the Ancient World, literature was thought of as something spoken or heard since the texts were read aloud. It was, therefore, a matter of the organs of speech and hearing, not of sight. As the text came to be considered as something revealed visually to the understanding through the written word (a development that may have had something to do with the spread and triumph of Christianity and its emphasis on a revealed truth recorded in the written text of the Gospels), so did the appearance of the text become a matter of concern. It could be decorated and embellished, whereas before only simple linear text divisions or diagrams or illustrations necessary for the understanding and clarification of the text, were considered suitable.[2]

The second point concerns the people involved in the writing and reading of ancient literature, who were for the most part slave copyists and readers. Only as the owner of the book became directly involved in its perusal and as the maker of it (who might, of course, be the same person) became a relatively free agent, did there arise the necessary conditions of artistic independence, and therefore, of interest in the embellishment of the text.

This point of the artist's independence in decorating a book is certainly a vital one to any understanding of the medieval initial. There can be no doubt that the greatest period for the creation of decorated letters was the early Middle Ages, the period from the seventh to the twelfth century. This was the period of monastic book production, in which very often the monks were writing and decorating books for the use of their own community, whether in the celebration of the liturgy in church or in the meditation enjoined in the cloister by the rule of Saint Benedict (died c. 550). Often scribe and artist were one and the same person.[3] We thus find in this period, to an extreme degree, the two factors already mentioned: personal use, that is, visual perusal of the text, and personal independence in the decisions preceding its making; which goes far to explain the vitality and originality of this period in the creation of decorated letters.

In the later Middle Ages the variety and creativity of the Early Medieval and Romanesque periods were no longer found to quite the same extent. This must in part be explained by a new situation in book-making with the emergence of a book trade whereby paid, lay craftsmen specialized in different tasks, and initials came to be executed mechanically by the assistants in workshops who had little opportunity to assert their own individuality. The appearance of the printed book did not, of course, result in the immediate disappearance of the decorated letter. But again, there was not the same relationship between individual craftsman and individual use. Moreover, although decorated letters have continued to be designed down through the centuries to the present, printers naturally think in terms of fonts of type, that is, complete alphabets, so that letters can be repeated as required. The result, however original in design, can still not equal the inexhaustible variations and diversity of the individual—"personalized" to use a modern term—decorated letters of the Middle Ages.

Since medieval decorated letters are so individual and so varied, a third important factor throughout their history must be borne in mind. This is the whole question of how we read script and, in general, the relationship of the decorated to the undecorated letters. Script is legible in so far as it is composed of clearly defined forms which are regularly repeated with the same significance. A vital aspect of the training of the scribes of the Middle Ages was in obtaining this regularity and distinctness of letter forms, since any ambiguity or variation could only lead to confusion and illegibility. Printing, of course, solved the problem of regularity, though not always of clarity and distinct forms. On the other hand, ambiguity and variation are vital elements in many forms of medieval decoration. Thus, from the start the decorated letter was an illogical combination of opposed requirements in so far as the decoration varying from letter to letter might result in a loss of legibility, and also in so far as it might render the expected form of the letter unrecognizable by distorting or altering it.

In the Plates which follow, some letters will be instantly recognizable to every reader accustomed to seeing the classical Roman capitals still in use today (Plates 7, 15, and 38), but many others will probably not be. Of course, those others were by no means necessarily unrecognizable at the time of their production, since the original readers will have had different patterns of expectation from ours. But if we treat these two opposing requirements—on the one hand regularity and legibility, on the other variation and decoration—as opposing poles, we shall see that the letters in this book vary between them, and satisfy the opposing requirements in different degrees. The emphasis on the letter form as independent and unvarying is thus, on the whole, a feature of classicizing periods such as the Carolingian Renaissance (Plates 6–8) or the Italian Renaissance (Plate 38), while the wish to alter and fragment the letter form is an anticlassical, medieval trend (Plates 1, 4, and 36).

The earliest decorated initials illustrated here are found in a famous manuscript of Virgil, the so-called *Augusteus.* Only seven leaves of this now survive.[4] The decorated letters occur not at particular text divisions but at the top of each page introducing whichever line of verse happens to fall there. Thus, originally there must have been as many initials as pages of the manuscript (calculated at about 657 pages), making the original manuscript an incredibly *de luxe* production. Carl Nordenfalk has grouped the earliest initials into three categories according to their ornament, "filling ornament," "added ornament," and "substitution ornament." The decoration of the surviving Virgil initials is mainly of the first kind, with some very small embellishments of added ornament. The thickness of the letter form is ornamented with simple patterns in green, orange, and yellow (Figure I). Since

ruler and compass were used to draw these initials, it is possible that they were executed by the scribes who used these tools in the preparation of the page for writing, although Nordenfalk suggests that different craftsmen were involved in the making of even the few surviving initials. It seems likely that the Virgil manuscript was made towards the end of the fourth century.

During the following three centuries experiments with initials were carried out in the Mediterranean countries, and decorative motifs were used both as filling and added ornament. In some examples living forms, especially birds or fish, were used as added or as substitution ornament. However, as Nordenfalk stresses, the clear basic form of the scribal alphabet was always respected.

The next step in the development of the decorated letter occurred in the British Isles and specifically, it seems, in Ireland early in the seventh century. The so-called *Cathach* connected by tradition with Saint Columba (*cathach* means "battler" in Irish, and the manuscript was carried into battle as a talisman) is now generally thought to have been made in the early seventh century, in other words, after Saint Columba's death in 597. The initials in black pen are ornamented with spirals and other patterns and in the *Q* on folio 48, the tail turns into a fish with a Cross above it (Figure II).[5] The initials of the *Cathach* already introduce two principles which would come to characterize the later initials produced in the British Isles during the seventh and eighth centuries. The first is the principle of metamorphosis by which one form can merge with and turn into another, resulting in a constant ambiguity and uncertainty. Secondly, the initials are accompanied by other larger letters which gradually decrease in size, thus forming a bridge between initial and the main text script. Both principles are seen on the great initial pages of the later Gospel Books. For example, in the *Lindisfarne Gospels* (Plate 1) the extremities of the *E* of the word *Evangelii* in the second line turn into birds' heads, and both on this page and in the *Book of Kells* (Plate 2), there is a diminution in the size of the letters.

In looking at the initials of this anthology it will become clear that they cannot be treated as an isolated artistic phenomenon. On the contrary, they reflect the styles of the particular time in which they were made. The relationship of the initial to the page and the use of framing devices have to be seen in the context of the attitude of the artists of a given period to problems of representation and of spatial organization in general. In the *Augusteus* (Figure I) the letters are separate and clear and seem to stand firmly on the ruled line, the slight widening at head and foot of the straight bars of a letter *T*, for instance, adding to the impression of stability and compactness, as Nordenfalk has pointed out. In the Insular manuscripts, however, classical space in which objects exist with their own identity, is replaced with a two-dimensional interlacing space, and so the initials too begin to merge and interlace, for example the *an* of *Evangelii* in the *Lindisfarne* page (Plate 1). Monograms are frequently found in Late Antique inscriptions, but there the skill lies in coordinating the undistorted letter shapes. On the pages of the *Lindisfarne Gospels* and *Book of Kells*, letters no longer have a separate identity, nor are they anchored to a particular spatial context. They can grow or contract, intertwine or merge as the artist requires. In this way they grow into symbols, "magical signs," as Hans Jantzen has observed, conveying the mystery of the Divine Word by their very complexity.[6]

If the letter form can be varied and altered and if the illustration need not be seen in terms of spatially convincing illusionism, then a situation arises in which it is possible to combine the two. It seems likely that Insular artists were the first to do this. In the *D* of the *Vespasian Psalter* (Figure III) the letter acts as a frame for the scene of David fighting the lion, and since that scene is itself represented in a form

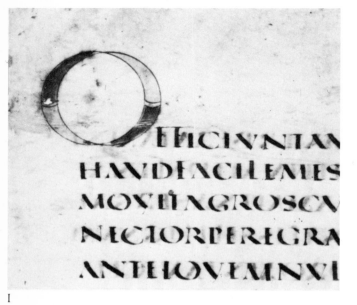

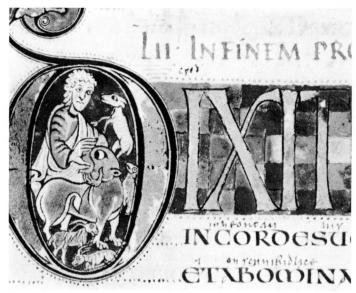

I

III

II

of two-dimensional, flattened space in which lion and man are interlaced like a band of strap-work, there is no spatial illogicality.[7] This is a development from certain earlier examples where a human head is enclosed in the bowl of a *P*, for example, a form of added ornament without meaning.[8] The historiated initial which links text and illustration in a particularly intimate manner, continued to be used throughout the Middle Ages with varying solutions to the problems of spatial representation that arose, as we shall see.

In France in the eighth century during the Merovingian period, artists also developed the idea of substitution ornament. But whereas Insular artists' initials are always full of movement, what Wilhelm Koehler has called "kinetic energy,"[9] and forms are constantly changing both in direction and in identity, Merovingian initials are composed most often of birds and fish which, paradoxically in view of their constant natural movement, are static and fixed in form. Thus, they cannot be twisted and shaped into endless different contortions to fit different contexts. They only exist as straightened or rounded shapes and so were used either for the uprights or for the curved parts of letters. The birds and fish do not generate any movement but are rather combined like matchsticks as Otto Pächt has observed

(Plate 3).¹⁰ Here too there is a tendency to distortion which often leads to illegibility.

In the *Gellone Sacramentary* from the late eighth century, we meet another type of substitution ornament in which certain letters are constructed of human figures (Plate 4). Such letters are not necessarily historiated initials, that is, having a narrative or symbolic significance specifically connected with the text they introduce, although of course they can be. It is not certain where the idea of the figure initial originated. A copy of Philippus Presbiter's *Commentary on Job*, assigned by E. A. Lowe to an Anglo-Saxon center on the Continent and dated in the first half of the eighth century, has a number of figure initials (Figure IV).¹¹ For example, in a *V* a man is shown in active combat with a beast whose tail turns into a piece of interlace. Perhaps this type of initial, like the historiated initial, was invented in the British Isles (though no examples survive) and copied in Continental scriptoria in the eighth century.

It was an obvious step to combine the idea of the figure initial with the historiated initial, and this is done in the *Gellone Sacramentary* where the *I* (Plate 4) represents the Virgin and the text is the Mass for the Vigil for the Nativity of Christ. Other initials have a narrative content with figures shown in action, an example being a *D* with the Jew, Judas, excavating the True Cross. Another late eighth-century manuscript with numerous remarkable historiated figure initials is the *Psalter* from Corbie in North France.¹² A round uncial form of *D* introducing the Canticle of Habbakuk (Figure V) is composed of a figure driving a chariot. This refers to verse 8—"thy chariots of salvation"—since the chariot is also shown in the ninth-century *Utrecht Psalter* made at Rheims.¹³ This thus introduces another form of medieval illustration known as "word illustration" in which particular words or phrases are illustrated, rather than a particular narrative scene of symbolic significance. In the initial each form is metamorphosized into the next in a way typical of Insular art, the driver's hat turning into his chariot and the chariot into the horse. Whereas in the *D*, the figure, chariot, and horse form the letter, in another initial, an *N* introducing the Canticle of Simeon (Luke 2:29) in which the Presentation in the Temple is shown, the letter is still vestigially present since its transverse bar is drawn in (Figure VI).

The numerous initials of the *Corbie Psalter* show great variety and imagination in the use of decorative patterns, of animals, birds, and fish as well as of human figures. Various scholars have drawn attention to their proto-Romanesque qualities and indeed it can be demonstrated that artists of two and three centuries later made direct copies of them.¹⁴ Such developments in the metamorphosis of the letter shape, which anticipated Romanesque initials, were, however, temporarily halted by the new classicizing tendencies, the result of a conscious policy on the part of the Emperor Charlemagne (died 814) and his advisors. In ninth-century manuscripts such as the *Vivian Bible* (Plate 7) the letter form stands out clearly and unambiguously on the page, and the shape and proportion of the letter is that of the monumental epigraphic capitals of early Imperial Roman inscriptions. One Carolingian manuscript significantly contains a pattern alphabet of such capitals.¹⁵ The return to classical letter shapes did not necessarily mean the abandonment of decoration, however. Insular influence remained particularly strong since many Insular books were on the Continent as a result of the Anglo-Saxon and Irish missions which had converted much of Northern Europe to Christianity. Moreover, prominent at Aachen among Charlemagne's advisors was an Englishman, Alcuin of York. Thus, in the group of sumptuous Gospel Books produced in the Emperor's court scriptorium the initials are clearly based on Insular designs (Plate 6). In the *Harley Gospels* (Plate 5) the artist also takes up the idea of the

IV

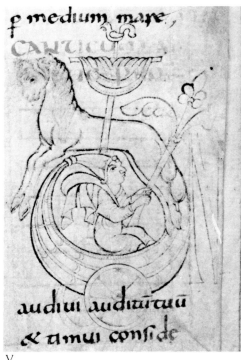

V

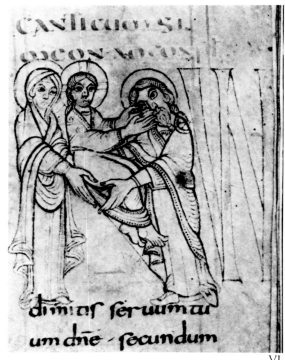

VI

historiated initial. The Insular-derived interlace panels, however, serve to clarify rather than fragment the shape of the letter which functions here as a window frame for the scene beyond, as it will in later examples of the fifteenth century (Plate 39).

On this page of the *Harley Gospels,* although something of a classical space construction survives and although some of the patterns are antique in origin (the placing of capitals in gold on purple panels also occurred in Late Antique *codices purpurei*), nevertheless, the total effect is unclassical due to the filling of every part of the page with pattern and the use of such rich and varied color. In later manuscripts of the so-called Franco-Saxon school of the time of Charlemagne's grandson, Charles the Bald, it is paradoxical that, although the decorative vocabu-

lary and the use of interlace, dotted patterns, and bird and animal heads, are all Insular in origin (Plate 9), the result can be, as Joachim Gaehde describes it, "a work whose monumental clarity and order may be termed more classical than any other initial page made for Charles the Bald elsewhere."[16]

Historiated initials were also used in the *Sacramentary* made for Archbishop Drogo of Metz c. 844–55 (Plate 6). In these we see the artist introducing plant foliage as a major part of the decoration. Leaf forms as added or filling ornament occurred earlier, of course, although they were never as important as here, and in Insular art they scarcely occur at all. Here the scroll fills the letter leaving only a small amount of space for the scene, and it also uses the letter shape as a trellis to climb on. Foliage is also used in the Carolingian Tours school (Plates 7 and 8) and with increasing richness and variety in later ninth-century manuscripts. On another page of the *Drogo Sacramentary* the words of the Canon, *Clementissime*, are capitals festooned with foliage scroll (Figure VII), but despite this they remain perfectly clear and legible. The page is a brilliant piece of design in the way the twelve letters are laid out balancing each other both vertically and horizontally. It is a kind of classical inscription with added enriching decoration. In a later manuscript such as the *Codex Aureus* of Charles the Bald (Plate 10), however, the letters are so embedded in the foliage that they are in danger of being completely submerged, and the page is thus reminiscent of certain Insular initial or carpet pages.

The problem of combining leaf scroll and letter was solved in a new way by artists at the Monastery of Saint Gall in the later ninth century.[17] The first step was to flatten the scroll so that it lost most of its organic and classical quality. It was usually painted in gold or silver which further emphasized its abstract nature. In many initials the letter form is a trellis as in the *Drogo Sacramentary* (Plate 6), but the flattened scroll forms a two-dimensional interlace, and so, although the outline shape of the letter usually remains clear, the scroll does not have the effect of suggesting a third dimension as it does in the earlier Metz manuscripts. The Saint Gall initials were copied by the earlier artists of the Ottonian period in Germany in the tenth century, who also adopted the practice of placing the scroll on a purple ground, which projects it forward and at the same time acts as a static foil to its two-dimensional movement and complexity. Sometimes contrasting grounds or patterned grounds were used, as in the *Petershausen Sacramentary* (Plate 11). The way in which the initial is projected forward was further emphasized by using framing devices and overlappings. Here again the space construction of contemporary Ottonian artists by means of overlapping planes in their miniatures is equally applied to the initial pages (Plate 12).[18]

The development in Anglo-Saxon initials of the tenth century was very different. In a Psalter made at Winchester in the time of King Athelstan (died 939) the initials formed of interlace and human and animal forms were clearly based on the minor initials of Southern English manuscripts of the later eighth century (Figure VIII).[19] However, a new feature was a three-dimensional, organic, curling leaf scroll, and all the forms used in the initials became more three-dimensional. The origins of the scroll are probably eastern Mediterranean, although how it was transmitted into England where it first appeared on certain embroideries made at Winchester c. 909–916 and later given by Athelstan to the shrine of Saint Cuthbert at Chester le Street (they are now at Durham) is unclear. As Francis Wormald put it, these initials are formed of a piece of inhabited scrollwork twisted into shape.[20] Although this makes for great variety in the many initials in the Psalter, the definition of the basic letter shape is lost, and consequently the letters are hard to recognize.

14

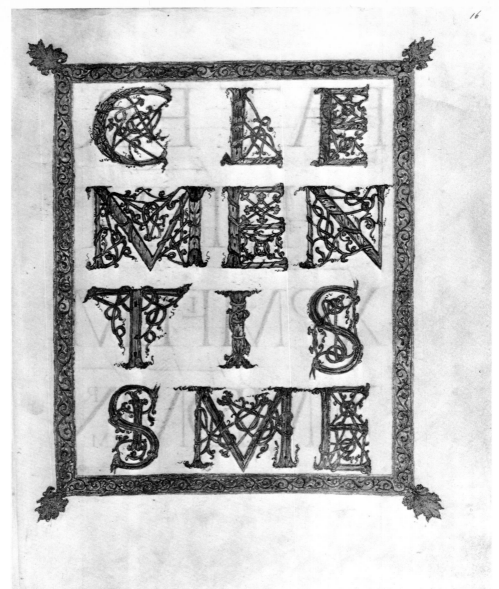

VII

In the mid-tenth century the leaders of the Anglo-Saxon church, particularly Saint Dunstan, Archbishop of Canterbury (died 988) and Saint Ethelwold, Bishop of Winchester (died 984) introduced monastic reforms which were based on Continental customs of the Carolingian monastic reform movements. Saint Dunstan spent a short period of exile in Ghent, and from such contacts it seems that Carolingian illuminated manuscripts arrived in England. For example a Sacramentary, the so-called *Leofric Missal,* made in the area of Arras c. 900, came to Glastonbury where Saint Dunstan had been abbot, and where additions were made to it before 979.[21] The original initials are in the Franco-Saxon style (Plate 8). Such initials suggested a new solution to the English artists of the problem of combining the letter form and the scroll, and the artist of the *Harley Psalter* in his initial *B* (Plate 15) produced one of those perfect answers to a particular problem, which continue to be copied with only slight variations by later artists, in this case for a period of over two-hundred years (Plate 20 and Figure X). The solution is to contrast the architectonic, rigid form of the monumental *B* whose flat form is emphasized by gold panel frames, with the dynamic multicolored scroll whose turning movement echoes the curves of the letter and by breaking out and curling over at a few points, also emphasizes its containing shape.

In the early eleventh century as the newly reformed Benedictine communities in North France and Normandy recovered from the political chaos caused by the Viking invasions of the tenth century, Monasteries such as Saint Bertin, Saint Vaast, Saint Amand, Mont Saint Michel, and Fécamp turned again, on the one hand, to their heritage of the Carolingian period, particularly to manuscripts of the Court School of Charlemagne and of the Franco-Saxon school, and on the other hand, looked with admiration upon the products of the flourishing English monastic scriptoria across the Channel. For example in the *Gospel Book of Saint Bertin* (Plate 21) the *Q* of Saint Luke can be compared both with the *Q* of the Carolingian *Harley Gospels* (Plate 5) and with the *D* of the Anglo-Saxon *Arundel Psalter* (Plate 16), and the scroll in the border is clearly Anglo-Saxon in origin (Figure VIII).

Another development in Continental manuscripts is observable in the scroll work initials of the type of the *Harley B* (Plate 15) which became inhabited by human figures and animals. This happened in some of the initials of the *Saint Vaast Bible* (Plate 22) and in certain early Norman initials such as the *B* in an Augustine *Commentary of Psalms,* written at Mont Saint Michel c. 1040–1050 (Figure IX).[22] The hunt going on in the border of the *Saint Bertin Gospels* (Plate 21) has been transferred here to the letter. The final step was for the inhabited scroll initial to become the historiated scroll initial in a *B* from another Augustine *Commentary on Psalms,* this time from Saint Evroul in Normandy, in which episodes from King David's life such as the fight with the lion and the combat with Goliath take place as if in an entangled wood (Figure X).[23] Anglo-Saxon artists (Plate 16) retained a free space for the figures of their initials as did the artist of the earlier *Saint Bertin Gospels* (Plate 21), and it is only after the Norman Conquest that these inhabited scroll initials became common in England (Plates 17 and 18, Figure XI). In other words, in this as in many other ways Norman artists introduced the Romanesque style into England, for as Otto Pächt has shown, the replacement of the fluid space of classical art by this "interwoven" form of space is a feature of the early Romanesque period (Figure XI).[24]

For a time indeed the attraction of the initial became so powerful that independent scenes were drawn into it (Plates 17–20), and this happened not only in France and England, but in Spain, Italy, and Germany (Plates 24–26). The ingenuity of Romanesque artists in designing decorated or historiated initials, an ingenuity prefigured in the *Corbie Psalter* (Figures V–VI), led to endless variations. This inventive variety is a keynote of Romanesque art as Meyer Schapiro has

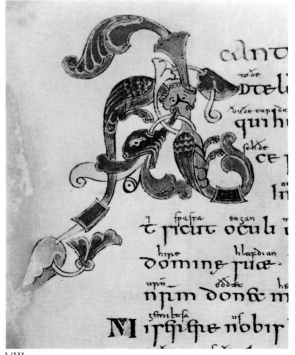

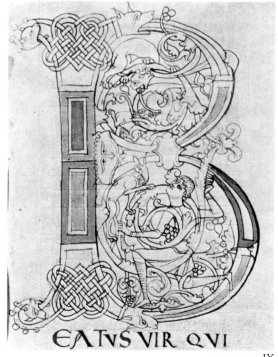

stressed.[25] The initials have been compared to Romanesque carved stone architectural capitals in which there was the same problem of the pre-ordained form into which scene or ornament had to be fitted. Just as all the capitals in a nave arcade will vary, so will each initial in a book. And just as the shape and supporting function of the capital is respected, so also will be the form and function of the letter.

One of the commonest themes of these decorated letters is combat or aggression between humans and animals, and the entwining scroll—for instance, in a V in a mid-twelfth-century English Bible (Figure XI).[26] This arises inevitably as part of the aesthetic of interwoven space. But the question of whether such initials were intended to have meaning has also naturally been asked. It is very seldom possible to detect any direct connection with the texts, and the conclusion must be that if there is any meaning it can only be some very generalized variation on the theme of the struggle between good and evil, or of the soul's upward striving. Many Romanesque initials, for instance, contain figures who climb up the letter or in the scroll, "gymnastic" or "clambering initials" as F. Wormald and C.R. Dodwell have called them.[27] An interesting early example is in a Reichenau school *Lectionary* of the eleventh century (Plate 14).[28] The letter *I* up which the man is climbing introduces the Lection for the Vigil of Easter Day and so has nothing to do with the Entry to Jerusalem or Christ and Zacchaeus, scenes in which figures climbing trees occur. Thus, if it is intended to have a meaning, it can only be a generalized one.

Such initials can be seen in part as a product of an unreal world of the imagination, which is reflected in literary terms in the combats of the romances and *chansons de geste,* and in religious terms in the struggles and fantastic tortures of the saints suffering from wild beasts, devils, and their human persecutors. In part,

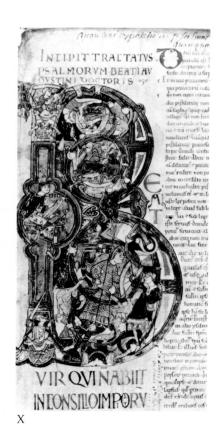

X

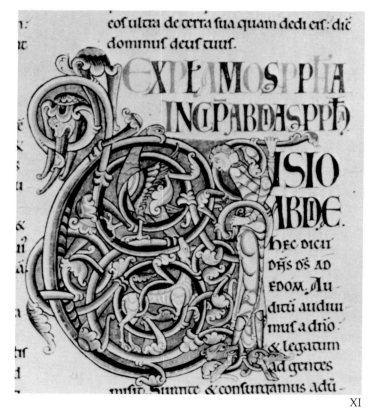

XI

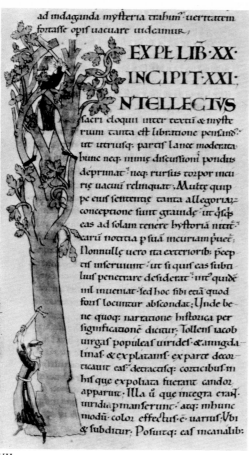

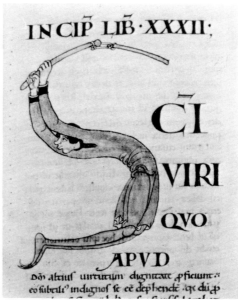

XII

XIII

they can also be seen as the product of more mundane preoccupations. Carl Nordenfalk has drawn attention to similarities with the acrobatic world of the circus, and another major theme clearly was hunting (Plate 21, Figures IX, XI).[29] Even members of religious orders were not free from the attractions of the chase, and the unreformed Canons of Mont Saint Michel, for instance, were accused of spending all their days in this way. Such themes are generalized, however, and only very occasionally is there any sense of the initials drawing upon actual observation of everyday activity. One example was in the illustration of calendars (Plate 17), but this went back to an earlier tradition. The initials in the volumes of a *Moralia in Job* of Gregory the Great, written at Cîteaux, are thus remarkable in this respect as well as for the real humor they display (Figures XII–XIV).[30] The first Abbot of the reformed community, Stephen Harding, was an Englishman, and it is tempting to think that these initials might be by an English artist and an early example of a native genius for satirical observation (note, for instance the tattered habits of the brethren) and for caricature of a type to be seen later in Hogarth and Rowlandson.

The *Moralia in Job* volumes were completed in 1111, a year before the arrival of Saint Bernard at Cîteaux, who must surely have seen them. He was later to write a blistering attack on the fantasy world of Romanesque art, criticizing the carved capitals in the Cloister both as a distraction to meditation and as a needless extravagance. A Cistercian statute enforcing simplicity in initials—which were to be painted in a single color and without gold — may thus owe its origin to his strictures. This statute as well as Saint Bernard's criticisms both surely imply that such decorated letters were not generally seen by contemporaries as having an essentially moral message to impart. Rather, as Meyer Schapiro has put it, they were a sign of a pagan attitude of spontaneous enjoyment and curiosity about the

world. This attitude continued to find expression in the borders of Gothic manuscripts where, incidentally, we encounter the same problems of interpretation.[31]

The Cîteaux initials are figure initials with scenes of the activities of the brethren, which, however, have no connection with the text. Romanesque artists also often designed historiated figure initials, a striking example being the *T* in a *Homiliary* from Le Cateau in North France (Figure XV).[32] Here the Emperor Heraclius is shown returning the True Cross to Jerusalem, struggling under its weight, the Cross being the letter *T*. Other examples of historiated initials ingeniously combining or including scenes are in the *Winchester Bible* showing the Ascent of the Prophet Elijah (Plate 19A) and the *Corbie Florus* (Plate 24). In this latter manuscript the artist, Felix, represents himself in a roundel in the stem of the letter.[33] This is significant for he is a lay professional contrasted with the monastic scribe shown at work in another roundel. Already, therefore, there was a separation of activities which would later lead to specialist craftsmen working in great urban centers, above all university and commercial cities. Maker and user were no longer the same, and the gap between scribe and illuminator also widened, since they no longer worked in the same physical setting of the monastic enclosure.

If this is one factor which helps to explain the decline of the decorated letter in importance, another, perhaps even more important one, was the gradual return of an interest in naturalistic representation, which would eventually lead to the realistic portrayal of both exterior and interior space, bringing with it particular problems for the book illuminator. In the thirteenth century the interwoven space of the Romanesque period was gradually replaced with what may be called "transparent" space (taking the term from Hans Jantzen's analysis of High Gothic architecture).[34] This organization of scene, foliage scroll, letter form, and background in a series of diaphanous layers can be seen in the initials of the *Bible of Robert de Bello* (Plate 28) or those of the *Beaupré Antiphonal* (Plate 33). It is instructive to compare this Gothic attitude toward space with two later examples of the same Resurrection scene: one in an *R* in an early fifteenth century Italian *Gradual* (Plate 37), the other in an *R* in a *Gradual* painted by Girolamo da Cremona in 1473 (Plate 39). We not only see the transparent layers of space with the abstract gold background (Plate 33) being replaced by a deep landscape background; the letter itself now acts as a window frame onto a real world and itself becomes a three-dimensional object. The hint of a column for the upright of the letter *R* in the early fifteenth-century manuscript was fully realized in Girolamo's initial.

Inevitably the renewed interest in the real world meant that the miniature regained its primary importance, and the initial even when historiated became subsidiary in most contexts. In some classes of manuscripts, however, it continued to be employed as the main form of decoration even against the trend, particularly in Bibles, as late as the fifteenth century (Figure XVI). In the thirteenth-century *Lectionary of the Sainte Chapelle*, although the illustration seems at first sight to be composed of historiated initials, the *I* is not really an independent letter, but a series of little miniatures placed one above the other (Plate 32). In the initials for the Book of Genesis in Bibles, too, the letter was often made up of independent roundels with scenes of the Creation, roundels which recall the design of contemporary stained glass (Plate 28).

Two other aspects of thirteenth-century Gothic illumination require comment. The first, which also connects with the newer freer spatial construction, is the growth of border ornament and particularly of marginal scenes. Humans, birds, and animals which before were entangled in the Romanesque interwoven space of the initial scroll, gradually freed themselves and escaped into the borders. In one

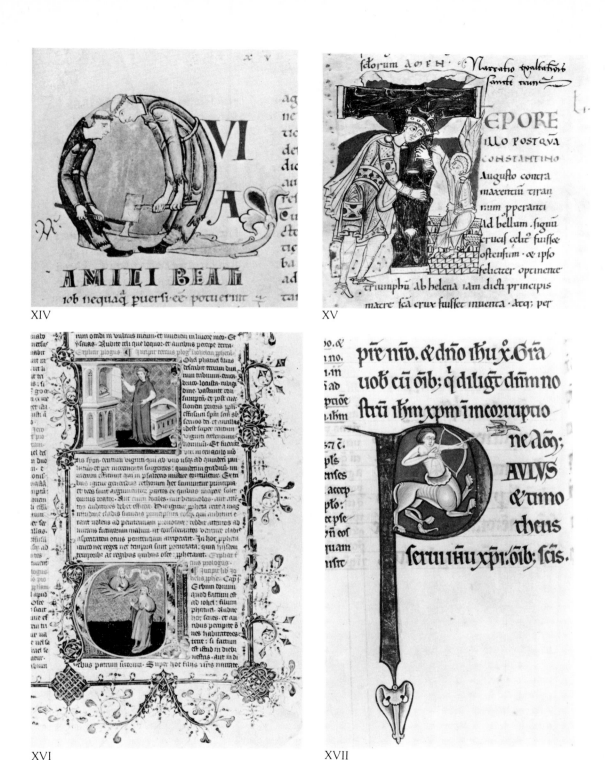

XIV

XV

XVI

XVII

late twelfth-century example, a Peter Lombard *Commentary on the Psalms,* a centaur shoots an arrow at a bird which has actually flown out of the initial *P* into the text to escape (Figure XVII)![35] In this way much of the imaginative fantasy and curiosity which in the Romanesque period had gone into the initials, was now channelled into the border ornament.[36]

nullam caulam muenio. Exiuit
ergo ihs portans spineam coro
nam : et purpureum uestimen
tum. ¶ Sã Tiburtij mris. euuãg̃
Nichil opertum. ij. xxviij.
Euangelium secundu eius euangelium.
Attendite a falsis. ij. xxxij.
In vigilia assumpcois b̃e mar̃.
Secundum lucam.
N illo tr̃ : Factum est dum lo
queretur ihs ad turbas : extollens
uocem quedam mulier de turba.
dixit illi. Beatus uenter qui te
portauit : et ubera que suxisti. At
ille dixit. Quinimmo : beati qui
audiunt uerbum dei : et custodiunt
illud.
In die euuang̃. ¶ Sedm lucam.

The second point concerns the evolution of a hierarchy of decoration, and also connects with the problems of emergent naturalism. The decorated borders began to form a transition from the painted miniature to the painted, gilded initial, and the further transition to the text written in black or brown ink was effected by the penwork initials with their filigree ornament usually executed in red and blue. The penwork may sometimes have been executed by the scribes, but there were also specialists for this work such as Jacquet Maci in Paris (Figure XVIII)[37] or the English artist of the *Windmill Psalter* (Plate 30). The latter seems also to have executed the figures, whereas Maci collaborated with other artists, notably Jean Pucelle.

These penwork initials developed out of the secondary, arabesque initials of Romanesque manuscripts.[38] Contemporaries knew them as *literae florissae,* that is, flourished letters or *lettres fleuronées,* as we know from accounts and payments. For example in a *Pontifical* whose illumination was completed for Pope Benedict XIII (elected 1394, deposed 1409), the payment for different sorts of initials is recorded, letters with figures (historiated initials in other words), letters without figures (these are in gold and colors with leaf scroll), letters called *champides* (that is, plain gold letters on blue and magenta grounds decorated with white filigree), and finally the *literae florissae.*[39]

It should not be forgotten that the initial at all times also had a function as a signpost to the reader, signaling divisions of the text. An interesting example of a text which makes this clear is contained in a copy of the *Sermons of San Bernardino* of Siena.[40] Headed *"Ordo scribendi secundum artem,"* the instructions direct that for each sermon the initial letter in red or blue is to be given a height of six lines of text, the other divisions of the *articula* and *capitula* being marked by letters of four lines or two lines respectively. Thus, as the text says, each division will become clearly apparent to the reader. The working out of such hierarchies of decoration is a continuous process in the history of book illumination and connects up intimately with the type of text and the reader's use of it. The organization of the twelfth-century *Gloss Books* is but one, though particularly intricate and spectacular, example of the process. Herbert of Bosham, for instance, in his preface of his edition of the Commentary of Peter Lombard on the *Psalter,* made between the death in 1170 of his master Archbishop Thomas Becket, and 1177, adjures scribes to follow the lay out carefully, and this must have included leaving spaces for the insertion of the initials for the Gallican and Hebraic versions of Saint Jerome's translation of the Psalms as well as for the different glosses (Figure XIX).[41]

In the thirteenth century there is very little depth in the miniatures and the figures move in a shallow platform space. As the space deepens, especially as a result of the influence of Italian artists from the late thirteenth century onward, the contradiction between the illusion of depth in the miniature or initial and the flat surface of the page on which the script was written grew more obviously illogical.[42] Thus, the frames of miniatures became, like the frames of wall or panel paintings, windows through which the spectator seems to look onto a real world. Just as the frames of miniatures were sometimes, from the later fourteenth century onward, shown illusionistically as if carved from stone or wood, so too the initials sometimes became three-dimensional objects.

In the North, Jean Pucelle, one of the first illuminators to take account of the new developments in Italy, resurrected during the second quarter of the fourteenth century in Paris the idea of the three-dimensional figure initial, which seemed to have fallen out of favor in the thirteenth century.[43] He designed such initials in his masterpiece the *Hours of Jeanne d'Évreux* of c. 1325–1328, and they also appeared in the works of his followers, for example the *Q* by the so-called Passion Master,

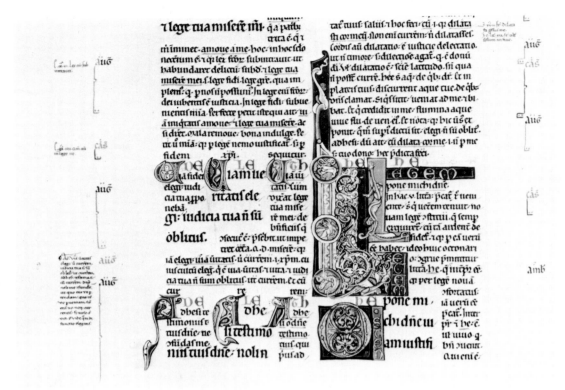

XIX

probably to be identified with Jean Lenoir, in a *Bible Historiale* (Figure XX).[44] Two cherubim with curved wings form the bowl of the letter inside which Abraham is sacrificing Isaac, and the tail of the letter is formed of a man standing holding a falchion and grasping the branch of the bowl of the letter. The *Bible* was made for King Charles V (died 1380), and a number of his charters also have striking figure initials showing the King himself.[45] Perhaps one of these was known to the English artist who drew the initial *R* in a charter of King Richard II of England of 1380 granting land in Oxford to the Fellows of Merton College who kneel before him to receive it from his hand (Figure XXI).[46] The figure initial is also particularly revived in Bohemian manuscripts of this period and in Milanese manuscripts probably under Bohemian influence (Plate 36).

Elsewhere in Europe there are other signs of artists having turned back to copy earlier forms of initial design, a particularly interesting case being the *Gospels of John of Oppava* (Plate 35), where there was probably a specific political motive behind the copying of earlier Carolingian initials. Another example is an anonymous treatise written at Avignon c. 1380–1390 where the idea of action unfolding in the context of the letter form, as seen in the *Winchester Bible* for instance (Plate 19A), is repeated in a more naturalistic context as figures climb a path winding up the length of the letter (Plate 34).

In Italy in the fifteenth century, artists reached two different solutions to the problem of combining script and initial. The first, adopted in the early humanistic manuscripts written in Florence during the first decade of the fifteenth century, was to return to the initials of eleventh to twelfth-century Tuscan manuscripts in which the flattened vine scroll of Ottonian manuscripts (Plates 11–12) had been used.[47] This historicism was natural in that the humanists were also copying the Caroline minuscule script of the same Italian manuscripts for their reformed humanistic

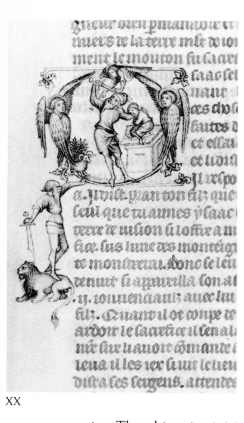

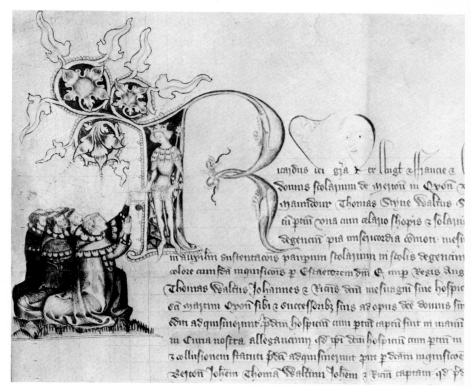

script. The white-vine initials with their schematized scroll did not conflict with the flat page, and the use of parti-colored grounds of red, blue, yellow, and green further emphasized the two-dimensionality of the initials. In later manuscripts, scenes were often inserted as little vignettes in the scroll in the initials and the borders, but in an initial such as the M showing painters at work in a Pliny *Natural History,* illuminated in Rome in the early 1460s, there is no attempt to work out a consistent spatial relationship (Figure XXIII).[48]

A totally different solution was adopted by certain artists in northeastern Italy, particularly in Padua, from about 1460 onward. The forms and the proportions of the letters were based on the seriphed capitals of early Imperial Roman inscriptions and they were shown as if three-dimensional objects. The initials in a copy of Strabo's *Geography* in the Latin translation of Guarino of Verona sent as a present to King René of Anjou by the Venetian general Jacopo Marcello in 1459, are of this type (Figure XXIV). Millard Meiss suggested that these initials were designed and perhaps some of them even executed by the great Paduan painter, Andrea Mantegna, who was himself a collector of classical inscriptions and knew many of the leading antiquarians of the time.[49] These epigraphic, facetted capitals occur in other manuscripts made in the Padua area and later spread elsewhere. Often play was made with their three-dimensionality, and figures sit on them or try to lift them up (Plate 38). Such initials were also used later by both Italian and German printers.

Another example of the letter becoming a three-dimensional object has already been referred to, the *R* by Girolamo da Cremona, where the upright of the letter becomes a column as if supporting a doorway or portico through which we look (Plate 39). In the North three-dimensional letters were also turned into objects in a deliberately amusing way, for example the *I* in an English early fifteenth-century

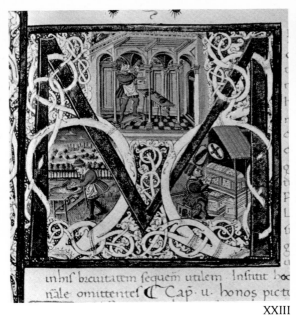

Bible, which becomes a cupboard containing Saint Jerome's books (Figure XVI),[50] or the initial *W* which in many of the manuscripts made for Wenceslas, King of Bohemia (died 1419), becomes the stocks in which the King himself is shown as imprisoned (Figure XXII).[51]

One other feature of the later Middle Ages, which is also probably to be interpreted as a consequence of the rise of the professional artist, is the appearance of pattern books with designs for decorated letters. Pattern books began to appear in the twelfth century, and several of them including one of the earliest, that from the Cistercian Abbey of Reun in Austria, contain designs for complete or partial alphabets of decorated letters.[52] Seven leaves now at Cambridge with a complete alphabet in which two of the letters are painted, the rest drawn in ink, are presumably a fragment of such a pattern book. Their style is similar to that of initials in Tuscan manuscripts of the mid-twelfth century (Figure XXV).[53] Often there are designs for different forms of a letter, majuscule or minuscule, Roman or uncial. On the page illustrated, for instance, there are two forms of *D*, Roman and uncial. Such patterns must have been used not only by illuminators and painters, but also by architects and sculptors. For example Reginald of Durham (died 1173) tells us that Bishop Puiset of Durham's architect, Richard, carried with him pictures of letters.[54]

Later examples are the complete figure alphabet in the sketchbook of the Milanese artist Giovannino dei Grassi (Plate 36) and the figure initials in the sketchbook of the International Gothic period in the Uffizi, Florence.[55] From the North two examples are the Göttingen pattern book with designs for initials and instructions on how to color them (a German manuscript of the mid-fifteenth century)[56] and an English pattern book with designs for initials and borders of the third quarter of the fifteenth century (Figure XXVI).[57]

All these alphabets presuppose some sort of repetition of the designs, even if slight variations could have been introduced. This repetition would have been incompatible with the love of variety characteristic of the Romanesque period. In the earlier period pages of decorated letters such as that in the ninth-century *Drogo Sacramentary* (Figure VII), in the eleventh-century *Psalter of Saint-Germain-des-Prés* (Figure XXVII),[58] or in the early twelfth-century *Psalter* from Saint Albans (Figure XXVIII),[59] although they seem at first sight rather like pattern book alphabets, belong in reality to a different tradition, that of carved or painted inscriptions. The letters, if they are repeated, are varied and they are not intended

XXIV

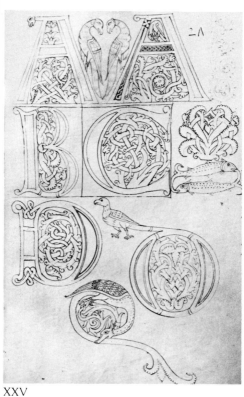

XXV

XXVI

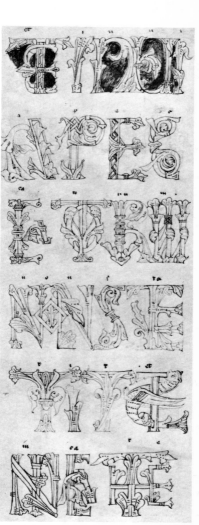

XXVII

in any way as patterns. Repetition was absolutely compatible with the new mechanical processes of the fifteenth century, on the other hand, and so we find a figure alphabet engraved by the German Master E. S. in the 1460s, in which certain of the letters from Giovannino dei Grassi's alphabet were repeated.[60] Here the objective was the wider dissemination of an artist's inventions which could either be copied or admired for their own sake. Later still, printers commissioned artists to design special alphabets of decorated letters for their books.

The pattern book alphabets for the use of artists also merged into the writing copy books with initials designed by writing masters as specimens of their skill and examples for their pupils to copy. An early example is the *Alphabet* of Mary of

XXVIII

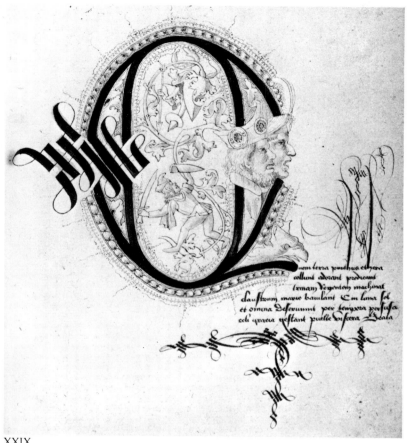

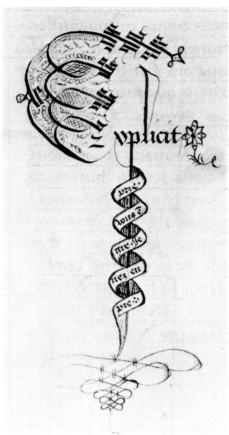

XXIX XXX

Burgundy of which two copies survive, one, perhaps the original, of c. 1480 in
Paris, the other of c. 1550 in Brussels (Figure XXIX).[61] The letters are ornamented
with pen-executed flourishes which were known as *cadeaux* in French and "cadels"
in English. They can be traced back to ornamental flourishing particularly in
charters of an earlier period. In the early fifteenth century, Jean Flamel, librarian of
Jean de Berry, inserted ownership inscriptions in the Duke's manuscripts or-
namented with cadels,[62] and later scribes, especially when writing the type of
script known as *bâtard* in Flanders and England used such cadels, for example,
Nicolas Spierinc in Bruges and Ricardus Franciscus in England (Figure XXX.)[63]
Another example is the initial by Jean Miélot of Lille (Plate 40). Here at the end of
the Middle Ages scribe and artist are again one and the same person, and once more
the result is initials of fantasy and imagination.

In the sixteenth century many of the writing books were printed, though
occasionally manuscript copy books were still made, for instance that by John
Scottowe, the Norwich writing master, of 1560.[64] Hand-produced initials are still
found in *de luxe* manuscripts by later calligraphers and in various special contexts,
one being the English Royal Charters which have carried on the tradition of the
initial historiated with a portrait of the monarch—seen in the Charter of Richard II
(Figure XXI) — into modern times.[65] But in general the demise of the hand-
produced book led inevitably to the disappearance of the individually designed and
decorated letter which had been a major vehicle of artistic invention for over a
thousand years.

Notes

1. C. Nordenfalk, *Die spätantiken Zierbuchstaben,* (Stockholm: 1970).
2. C. Nordenfalk, "The Beginning of Book Decoration," *Essays in Honor of Georg Swarzenski,* ed. O. Goetz. (Berlin, Chicago: 1951), pp. 9-20; K. Weitzmann, *Illustrations in Roll and Codex,* (Princeton: 1970).
3. J.J.G. Alexander, "Scribes as Artists," *Medieval Scribes, Manuscripts and Libraries: Essays presented to N.R. Ker,* ed. M.B. Parkes, A.G. Watson, (London: 1978).
4. C. Nordenfalk, *Virgilius Augusteus,* Codices selecti phototypice impressi, LVI, (Graz: 1976).
5. Dublin, Royal Irish Academy, s.n.; J.J.G. Alexander, *Insular Manuscripts 6th-9th Century (Survey of Manuscripts Illuminated in the British Isles, vol. 1),* (London: 1978), no. 4.
6. H. Jantzen, "Das Wort als Bild in der frühmittelalterlichen Buchmalerei," *Über den gotischen Kirchenraum und andere Aufsätze,* (Berlin: 1951), pp. 53-60. The most famous monogram is, of course, the *Chi Rho* of the Emperor Constantine's vision; see Nordenfalk, *Zierbuchstaben,* ch. III. For medieval monograms see N. Gray, *Lettering as Drawing. Contour and Silhouette,* (Oxford: 1970), pp. 61 ff.
7. London, British Library, Cotton Vespasian A.1; Alexander, *Insular Manuscripts,* no. 29.
8. Munich, Bayerische Staatsbibliothek, Clm 6436; Nordenfalk, *Zierbuchstaben,* p. 144, Taf. IV, Abb. 51-2.
9. W. Koehler, *Buchmalerei des frühen Mittelalters,* (Munich: 1972).
10. O Pächt, "The pre-Carolingian Roots of Early Romanesque Art," *Studies in Western Art. Romanesque and Gothic Art. Acts of the 20th International Congress of the History of Art,* ed M. Meiss et al. I (Princeton: 1963), pp. 67-75.
11. Cambrai, Bibliothèque Municipale, Ms. 470; E.A. Lowe, *Codices Latini Antiquiores,* (*C.L.A.*) VI, (Oxford: 1953), no. 740. See also J. Gutbrod, *Die Initiale in Handschriften des achten bis dreizehnten Jahrhunderts,* (Stuttgart: 1965), espec. pp. 97ff, 129ff. Other early examples are in the *Trier Gospels, C.L.A.,* IX, no. 1364, and the Saint Gall *Leges Barbarorum, C.L.A.,* VII, no. 950.
12. Amiens, Bibliothèque Municipale, Ms. 18; Exhibited, *Karl der Grosse. Werk und Wirkung* (10th Council of Europe Exhibition), (Aachen: 1965), no. 436.
13. E.T. Dewald, *The Illustrations of the Utrecht Psalter,* (Princeton: 1933), pl. 135.
14. See Pächt, *cit.* note 10. Also C. Nordenfalk, "Book Illumination" in A. Grabar, C. Nordenfalk, *Early Medieval Painting,* (Skira: 1957), p. 142. For later copies of the Psalter's initials see J.J.G. Alexander, *Norman Illumination at Mont St. Michel 966-1100,* (Oxford: 1970), pp. 53, 207-8.
15. Bern, Burgerbibliothek, Cod. 250; *Karl der Grosse,* no. 385a, pl. 36.
16. F. Mütherich, J. Gaehde, *Carolingian Painting,* (New York: 1976), p. 126.
17. For Saint Gall manuscripts see A. Merton, *Die Buchmalerei in St. Gallen,* (Leipzig: 1923). F. Landsberger, *Der St. Galler Folchard Psalter,* (Saint Gall: 1912).
18. The space construction of the Master of the Registrum Gregorii has been analyzed by C. Nordenfalk, "Der Meister des Registrum Gregorii," *Münchner Jahrbuch der bildenden Kunst* I (1950): 61-77.
19. E. Temple, *Anglo-Saxon Manuscripts 900-1066 (Survey of Manuscripts Illuminated in the British Isles, vol. 2),* (London: 1976), no. 7, ills, 1, 20-4, 26.
20. For the question of the origin of these scrolls see R. Freyhan, "The place of the stole and maniples in Anglo-Saxon art of the tenth century," *The Relics of St. Cuthbert,* ed. C.F. Battiscombe, (Oxford: 1956), pp. 409-32; F. Wormald, "Decorated initials in English manuscripts from A.D. 900 to 1100," *Archaeologia* XCI (1945): 117.
21. Oxford, Bodleian Library, Ms. Bodley 579; Temple, *Anglo-Saxon Manuscripts,* no. 17.
22. Avranches, Bibliothèque Municipale, Ms. 76, fol. 1; Alexander, *Mont St. Michel,* pp. 71 ff., pl. 12b.
23. Rouen, Bibliothèque Municipale, Ms. 456; F. Avril, *Manuscrits normands XI-XIIe siècles,* Bibliothèque Municipale de Rouen, 1975, no. 73.
24. Pächt, "Pre-Carolingian," pp. 74-5.
25. M. Schapiro, "On the Aesthetic Attitude in Romanesque Art," reprinted in *Romanesque Art. Selected Papers,* (New York: 1977), pp. 1-27.
26. Oxford, Bodleian Library, Ms. Auct. E. inf. 1-2; C.M. Kauffmann, *Romanesque Manuscripts 1066-1190 (Survey of Manuscripts Illuminated in the British Isles, vol. 3),* (London: 1975), no. 82, ills. 225-8.

27. Wormald, " Initials." C.R. Dodwell, *The Canterbury School of Illumination*, (Cambridge: 1954), p. 24.
28. I am grateful to Dr. W. Milde, Wolfenbüttel, for information on this manuscript.
29. Nordenfalk, "Book Illumination," p. 178.
30. Dijon, Bibliothèque Municipale, Mss. 168-70, 173; C. Oursel, *Miniatures Cisterciennes (1109-1134)*, (Macon: 1960), pp. 11ff., pls. XXI-XXXIV.
31. For Saint Bernard's strictures and the question of meaning see Schapiro, "On the Aesthetic Attitude," and Nordenfalk, "Book Illumination," pp. 154-6. For Cistercian single color initials see Alexander, "Scribes as Artists." For meaning in Gothic marginal scenes see L.M.C. Randall, *Images in the Margins of Gothic Manuscripts*, (Berkeley: 1966).
32. Cambrai, Bibliothèque Municipale, Ms. 528; Alexander, *Mont St. Michel*, p. 158, pl. 45c.
33. For examples of scribes and illuminators at work see V.W. Egbert, *The Mediaeval Artist at Work*, (Princeton: 1967), and Alexander, "Scribes as Artists."
34. H. Jantzen, *High Gothic*, (London: 1962), pp. 73ff.
35. Oxford, Bodleian Library, Ms. Bodley 725; O. Pächt, J.J.G. Alexander, *Illuminated Manuscripts in the Bodleian Library, 3. British, Irish and Icelandic Schools*, (Oxford: 1973), no. 232, pl. XXIII.
36. See Randall, *Images*.
37. Paris, Bibliothèque de l'Arsenal, Ms. 161; F. Avril, "Trois Manuscrits de l'entourage de Jean Pucelle," *Revue de l'Art* IX (1970): 37-48, figs. 1-9. F. Avril, "Un enlumineur ornemaniste parisien de la première moitié du XIVe siècle: Jacobus Mathey (Jacquet Maci?)," *Bulletin Monumental* CXXIX (1971): 249-64, fig. 3. F. Avril, "Autour du Bréviaire de Poissy," *Le Musée Condé* VII (1974): 1-6.
38. See Alexander, "Scribes as Artists," for literature on these initials. It is not uncommon to find penwork of this type added to Romanesque or even Carolingian initials. A striking example is the Franco-Saxon Gospels, Vatican, Pal. Lat. 47; C. Nordenfalk, "Ein Karolingisches Sakramentar aus Echternach und seine Vorläufer," *Acta Archaeologica* II (1931): 237, pl. XIIIb.
39. L. Delisle, *Le Cabinet des manuscrits de la Bibliothèque Nationale, I* (Paris: 1868), p. 491.
40. Paris, Bibliothèque Nationale, n. acq. lat. 572; C. Coudercq, "Instructions données à un copiste du XVe siècle," *Bibliothèque de l'école des chartes* LV (1894): 232. I owe knowledge of this text to MM. P. Gasnault and F. Avril, Bibliothèque Nationale.
41. Oxford, Bodleian Library, Ms. Auct. E. inf. 6; Pächt, Alexander, *Illuminated Manuscripts, 3*, no. 201. See also Alexander, *Mont St. Michel*, pp. 76-7.
42. For a masterly analysis of these problems see O. Pächt, *The Master of Mary of Burgundy*, (London: 1948).
43. K. Morand, *Jean Pucelle*, (Oxford: 1962); J. Rorimer, *The Hours of Jeanne d'Évreux*, (New York: 1957); F. Avril, *Manuscript Painting at the Court of France: The Fourteenth Century*, (New York: 1978), pls. 3-10.
44. Paris, Bibliothèque de l'Arsenal, Ms. 5212; F. Avril, "Une Bible historiale de Charles V," *Jahrbuch der Hamburger Kunstsammlungen* XIV-XV (1970): 47-76.
45. Exhibition catalogue, *La Librairie de Charles V*, Bibliothèque Nationale, Paris, (Paris: 1968), nos. 22, 24-7, pl. 4
46. Exhibition catalogue, *700 Years of Merton College, Oxford, 1264-1964*, (Oxford: 1964), no. 30.
47. See J.J.G. Alexander, *Italian Renaissance Illuminations*, (New York: 1977), pp. 12ff. with earlier literature.
48. London, Victoria and Albert Museum, Ms. AL. 1504-1896. For other manuscripts for the same owner, Gregorio Piccolomini Lolli, secretary of Pope Pius II and by the same illuminator see J. Ruysschaert, "Miniaturistes romains sous Pie II," *Enea Silvio Piccolomini – Papa Pio II*, (Siena: 1968), p. 258ff. Ruysschaert suggests the illuminator is to be identified as Giuliano Amedei.
49. Albi, Bibliothèque Rochegude, Ms. 4; M. Meiss, *Andrea Mantegna as Illuminator*, (Hamburg: 1957).
50. London, British Library, Royal 1.E.IX; M. Rickert, *Painting in Britain. The Middle Ages*, 2nd ed. (Harmondsworth: 1965), pp. 171, 248 n. 83, pls. 170a, 174.
51. Vienna, Österreichische Nationalbibliothek, Cod, 2760; J. Krasa, *Die Handschriften König Wenzels IV*, (Vienna: 1971), pp. 23 ff., 64ff., 142ff.
52. Vienna, Österreichische Nationalbibliothek, Cod. 507; R.W. Scheller, *A Survey of Medieval Model Books*, (Haarlem: 1963), cat. no. 9.
53. Cambridge, Fitzwilliam Museum, Ms. 83-1972. Bequeathed by Francis Wormald. P.M. Giles, "A handlist of additional manuscripts in the Fitzwilliam Museum, part VI. Accessions 1966-74," *Transactions of the Cambridge Bibliographical Society* VI. 4 (1975): 246.
54. "Reginaldi monachi Dunelmensis Libellus," *Surtees Society* I (1835): 111. I owe this reference

30

to Mr. Alan Piper. The phrase, taken with the other account of the miracle, ibid., p. 94, may only refer to some sort of written text, however.

55. U. Jenni, *Das Skizzenbuch der internationalen Gotik in den Uffizien*, (Vienna: 1976), pp. 65-75, with an important discussion of the figure alphabets.

56. H. Lehmann-Haupt, *The Göttingen Model Book*, (Columbia, Miss.: 1972).

57. London, British Library, Sloane 1448A; J. Backhouse, "An Illuminator's Sketchbook," *British Library Journal* I (1975): 3-14. A manuscript with designs for initials and borders, one of which has the signature and the date—Guinifortus de Vicomercato, 1450—is probably a sample book of the artist's skills, rather than a pattern book. It is in the Lilly Library, Indiana, See D. Miner, *2000 Years of Calligraphy*, (Baltimore: 1965), no. 38.

58. Paris, Bibliothèque Nationale, Latin 11550; Y. Deslandres, "Les manuscrits decorés au XIe siècle à Saint Germain-des-Prés par Ingelard," *Scriptorium* IX (1955): 3-16.

59. Hildesheim, Saint Godehard's; O. Pächt, C.R. Dodwell, F. Wormald, *The St. Albans Psalter*, (London: 1960).

60. A. Shestack, *Fifteenth-Century Engravings of Northern Europe from the National Gallery of Art, Washington D.C.*, 1968, no. 15, with earlier literature.

61. P. Dumon, *L'Alphabet Gothique dit de Marie de Bourgogne. Reproduction du codex Bruxellensis II.845*, (Brussels: 1972).

62. M. Meiss, *French Painting in the Time of Jean de Berry. The Late Fourteenth Century and the Patronage of the Duke*, (London: 1967), p. 290, pl. 845.

63. For Spierinc see A. de Schryver, "Nicolas Spierinc," *Scriptorium* XXIII (1969): 434-58. For Ricardus Franciscus see K. Scott, "A mid-fifteenth-century English illuminating shop and its customers," *Journal of the Warburg and Courtauld Institutes* XXXI (1968): 170 n. 3 (Ashmole 765 vice 764). He may also be responsible for the cadelled alphabet in Oxford, Bodleian Library, Ms. Ashmole 789, ff.1-5; Pächt, Alexander, *Illuminated Manuscripts, 3*, no. 1138, pl. CVI.

64. J. Backhouse, *John Scottowe's Alphabet Books*, Roxburghe Club, (London: 1974). I. Whalley, *English Handwriting 1540-1853*, (London: 1969). Oxford, Bodleian Library, Ms. Canon. Ital. 196 is a writing book by Giovanbattista Palatino made in Rome after 1541 with various alphabets of decorated letters; O. Pächt, J.J.G. Alexander, *Illuminated Manuscripts in the Bodleian Library, 2. Italian School*, (Oxford: 1970), no. 1010 with literature. An interesting German example is the writing book of Gregorius Bock of c. 1517, Yale University, Beinecke Library, Ms. 439; see W. Cahn, J. Marrow, "Medieval and Renaissance Manuscripts at Yale: A Selection," *Yale University Library Gazette* LII (1978): no. 82, pl. 31. I am grateful to Dr. Cahn for bringing this to my attention. A number of reading books for children also contain alphabets, though undecorated; see B. Volpe, "Florilegium alphabeticum: Alphabets in medieval manuscripts," *Calligraphy and Palaeography. Essays presented to Alfred Fairbank*, ed. A.S. Osley, (London: 1965), pp. 69-74.

65. See E. Auerbach, *Tudor Artists*, (London: 1954).

Bibliography

General Bibliography

A. General works on schools of illumination

Alexander, J.J.G. *Italian Renaissance Illuminations.* New York: 1977.
Avril, F. *Manuscript Painting at the Court of France: The Fourteenth Century.* New York: 1978.
Boeckler, A. *Deutsche Buchmalerei vorgotischer Zeit.* Königstein im Taunus: 1959.
—*Deutsche Buchmalerei der Gotik.* Königstein im Taunus: 1959.
Diringer, D. *The Illuminated Book: Its History and Production.* London: 1967.
Dodwell, C.R. *Painting in Europe 800-1200.* Harmondsworth: 1971.
Grabar, A., Nordenfalk, C. *Early Medieval Painting.* Skira, 1957.
—*Romanesque Painting.* Skira, 1958.
Grodecki, L., Mütherich, F., Taralon, J., Wormald, F. *Le siècle de l'an mil.* Paris: 1973.
Hubert, J., Porcher, J., Volbach, W.F. *Carolingian Art.* London: 1970.
—*Europe in the Dark Ages.* London: 1969.
Mütherich, F., Gaehde, J.E. *Carolingian Painting.* New York: 1976.
Nordenfalk, C. *Celtic and Anglo-Saxon Painting.* New York: 1977.
Porcher, J. *French Miniatures from Illuminated Manuscripts.* London: 1960.
Rickert, M. *Painting in Britain: The Middle Ages.* 2nd ed., Harmondsworth: 1965.
Salmi, M. *Italian Miniatures.* London: 1957.
Williams, J. *Early Spanish Manuscript Illumination.* New York: 1977.

B. General works concerned with initials

Gray, N. *Lettering as Drawing. Contour and Silhouette.* Oxford: 1970.
—*Lettering as Drawing. The Moving Line.* Oxford: 1970.
Gutbrod, J. *Die Initiale in Handschriften des 8. bis 13. Jahrhunderts.* Stuttgart: 1965.
Lehner, E. *Alphabets and Ornaments.* New York: 1952. Reprinted New York: 1968.
Massin. *Letter and Image.* Translated C. Hillier, V. Menkes. London: 1970.
Nesbitt, A. *Decorative Alphabets and Initials.* New York: 1959.
Nordenfalk, C. *Die spätantiken Zierbuchstaben.* Stockholm: 1970.
Schardt, A. *Das Initial.* Berlin: 1938.
van Moé, E. *La lettre ornée dans les manuscrits du VIIIe au XIIe siècle.* Paris: 1949.

Bibliography to Individual Manuscripts

Plate 1

T.D. Kendrick, T.J. Brown, R.L.S. Bruce-Mitford, H. Roosen-Runge, A.S.C. Ross, E.G. Stanley, A.E.A. Werner, *Evangeliorum Quattuor Codex Lindisfarnensis*, 2 vols. (Olten, Lausanne: 1956, 1960).

J.J.G. Alexander, *Insular Manuscripts. Sixth to the Ninth Century* (*Survey of Manuscripts Illuminated in the British Isles, vol. 1*), (London: 1978), no. 9, ills. 28–46, fig. 2.

Plate 2

E.H. Alton, P. Meyer, *Evangeliorum Quattuor Codex Cennanensis,* 3 vols., (Olten, Lausanne: 1951).

F. Henry, *The Book of Kells,* (London: 1974).

Alexander, *Insular Manuscripts,* no. 52, ills. 231–60.

Plate 3

E.H. Zimmermann, *Vorkarolingische Miniaturen,* (Berlin: 1916), pp. 87–8, 224, pls. 146, 148–9.

E.A. Lowe, *Códices Latini Antiquiores, V,* (Oxford: 1950), no. 630.

J. Porcher, "La peinture provinciale (regions occidentales)," *Karl der Grosse, Lebenswerk und Nachleben III. Karolingische Kunst,* ed. W. Braunfels, H. Schnitzler, (Düsseldorf: 1965), p. 55, pls. 21–2.

Plate 4

E. H. Zimmermann, *Vorkarolingische, Miniaturen,* pp. 9, 11, 14, 24, 89–91, 228, pls. 153–9.

V. Leroquais, *Les Sacramentaires et les Missels manuscrits des bibliothèques publiques de la France,* (Paris: 1924), pp. 1–8, pls. II–IV.

B. Teyssèdre, *Le Sacramentaire de Gellone et la figure humaine dans les manuscrits francs du VIIIe siècle.* (Toulouse: 1959).

Plate 5

W. Koehler, *Die Karolingischen Miniaturen, II. Die Hofschule Karls des Grossen,* (Berlin: 1958), pp. 11ff., 14, 15ff., 56–69, pls. 42–66.

F. Mütherich, "Die Buchmalerei am Hofe Karls des Grossen," *Karl der Grosse. Lebenswerk und Nachleben. III Karolingische Kunst,* ed. W. Braunfels, H. Schnitzler, (Düsseldorf: 1965), pp. 9ff., pls. V–X.

Plate 6

W. Koehler, *Die Karolingischen Miniaturen, III. 1. Die Gruppe des Wiener Krönungs-Evangeliar. 2. Metzer Handschriften,* (Berlin: 1960), pp. 143–62, pls. 75–87.

F. Mütherich, *Drogo Sakramentar, Ms. Lat. 9428, Bibliothèque nationale, Paris (Codices selecti),* (Graz: 1974).

Plate 7

W. Koehler, *Die Karolingischen Miniaturen, I. Die Schule von Tours.* (Berlin: 1933, reprinted 1963), I, pp. 27–64, 109–229, II, pp. 238–42, 250–55, 396–401, pls. 68–89.

P.E. Schramm, F. Mütherich, *Denkmale der deutschen Könige und Kaiser,* (Munich: 1962), pp. 33, 123, 129ff., pl. 42.

Plate 8

H.Y. Thompson, *A Descriptive Catalogue of Fourteen Illuminated Manuscripts,* nos. XCV-CVII, (Cambridge: 1912), pp. 53-4.

H.Y. Thompson, *Illustrations from 100 Manuscripts in the Library of H.Y. Thompson 3* (London: 1912), pls. 1–8.

E.G. Millar, *The Library of A. Chester Beatty,* I, (Oxford: 1927), pp. 42–3, pls. 16–19.

Koehler, *Die Karolingischen Miniaturen,* I, 1. pp. 296–8, 303, 409–10, pls. 115 a–e.

Plate 9

Peintures et initiales de la seconde Bible de Charles le Chauve, (Paris: 1911).

E. van Moé, *La lettre ornée,* (Paris: 1949).

Schramm, Mütherich, *Denkmale der deutschen Könige,* p. 135, pl. 54.

F. Mütherich, J.E. Gaehde, *Carolingian Painting,* (New York: 1976), pl. 48.

Plate 10

G. Swarzenski, *Die Regensburger Buchmalerei des X. und XI. Jahrhunderts,* (Leipzig: 1901), pp. 15, 18, 27, 29ff., 44, 49, 59f., 67ff., 71ff., 83, 86, 91, 108ff., pls. IV–VI.

Schramm, Mütherich, *Denkmale der deutschen Könige,* pp. 33, 131, 133, 134ff., 138, 139, 146, 157, pl. 52.

Mütherich, Gaehde, *Carolingian Painting,* pls. 35–8.

Plate 11

C.R. Dodwell, D.H. Turner, *Reichenau Reconsidered (Warburg Institute Surveys, II),* (London: 1965), pp. 8, 12, 13, 38–44, 56–62, 64, 67, 83, pls. 9, 10.

Exhibited, *Suevia Sacra. Frühe Kunst in Schwaben,* (Augsburg: 1973), no. 161, pl. 150.

Plate 12

M.R. James, *A Descriptive Catalogue of the Latin Manuscripts in the John Rylands Library at*

Manchester, (London: 1921), pp. 176–9, pls. 128–133.

C. Nordenfalk, "The chronology of the Registrum Master," *Kunsthistorische Forschungen Otto Pächt zu ehren,* ed. A. Rosenauer, G. Weber, (Salzburg: 1972), pp. 62–76, pl. 10.

Plate 13

W. Vöge, "Eine deustche Malerschule um die Wende des ersten Jahrtausends," *Westdeutsche Zeitschrift für Geschichte und Kunst. Ergänzungshefte* VII (1891): 99ff.

Schramm, Mütherich, *Denkmale der deutschen Könige,* p. 156, pl. 109.

Plate 14

O. Lerche, *Das Reichenauer Lektionar der Herzog-August-Bibliothek zu Wolfenbüttel,* (Leipzig: 1928), pls. 38–42.

W. Milde, *Mittelalterliche Handschriften der Herzog August Bibliothek,* (Frankfurt/a/M: 1972).

A. Weis, "Die spätantike Lektionar-Illustration im Skriptorium der Reichenau," *Die Abtei Reichenau. Neue Beitrage zur Geschichte und Kultur des Inselklosters,* ed. H. Maurer, (Sigmaringen: 1974), pp. 311–62.

Plate 15

E. Temple, *Anglo-Saxon Manuscripts 900–1066 (Survey of Manuscripts Illuminated in the British Isles, vol. 2),* (London: 1976), no. 41, ills. 140–42.

Plate 16

Temple, *Anglo-Saxon Manuscripts,* no. 66, ills. 213, 216–17, 220, fig. 56.

Plate 17

C. M. Kauffmann, *Romanesque Manuscripts 1066–1190 (Survey of Manuscripts Illuminated in the British Isles, vol. 3),* (London: 1975), no. 71, ills, 203–4.

Plate 18

C.R. Dodwell, *The Great Lambeth Bible,* (London: 1959).

Kauffmann, *Romanesque Manuscripts,* no. 70, ills. 192–5, figs. 30, 32, 36.

Plate 19

W. Oakeshott, *The Artists of the Winchester Bible,* (London: 1945).

Kauffmann, *Romanesque Manuscripts,* no. 83, ills. 229–39, figs. 26, 34, 38.

Plate 20

H.B. Graham, "The Munich Psalter," *The Year 1200. A Symposium,* intro. J. Hoffeld, (New York: 1975), pp. 301–312.

Plate 21

C.R. Dodwell, *Painting in Europe 900–1200,* (Harmondsworth: 1971), pp. 80–2, pl. 98.

Temple, *Anglo-Saxon Manuscripts,* no. 30 (xiii), ill. 112, fig. 41.

Plate 22

S. Schulten, "Die Buchmalerei des 11. Jahrhunderts im Kloster St Vaast in Arras," *Münchner Jahrbuch der bildenden Kunst* VII (1956): 79–81.

Dodwell, *Painting in Europe,* pp. 82–3, 145–6, pl. 100.

Plate 23

Leroquais, *Les Sacramentaires,* pp. 100–103, pls. XXIV–V.

J. Dufour, *La Bibliothèque et le scriptorium de Moissac,* (Paris: 1972), pp. 125–6, pl. LXXII.

Plate 24

C. de Merindol, *La production des livres peints à l'abbaye de Corbie au XIIe siècle. Étude historique et archéologique,* (Lille: 1976), (Service de reproduction de théses) II, pp. 834–38, pl. A.

Plate 25

J. Meurgey, *Les principaux manuscrits à peintures du Musée Condé à Chantilly,* (Paris: 1930), pp. 8–11, pl. VI.

S. Collon-Gevaert, J. Lejeune, J. Stiennon, *A Treasury of Romanesque Art,* (London: 1972), pp. 120, 222, 239–40, pl. 41.

Plate 26

R. Schilling, "Studien zur deutschen Goldschmiedekunst des 12. und 13. Jahrhunderts," *Form und Inhalt. Kunstgeschichtliche Studien Otto Schmitt zum 60. Geburtstag,* (Stuttgart: 1950), pp. 73–88.

H. Köllner "Ein Annalenfragment und die Datierung der Arnsteiner Bibel in London," *Scriptorium* XXVI (1972): 34ff.

Exhibited, *Die Zeit der Staufer.* Würtembergisches Landesmuseum, (Stuttgart: 1977), no. 716, pl. 507.

Plate 27

W. Neuss, *Die Apokalypse des Hl. Johannes in der altspanischen und altchristlichen Bibel-illustration* (Münster-i-W: 1931), pp. 32–4, 281, pls. 1, 2, 12, 17, 55, 72, 84, 93, 99, 116, etc.

J. Guilmain, "Interlace decoration and the influence of the North on Mozarabic illumination," *Art Bulletin* XLII (1960): 211–8.

J. Williams, *Early Spanish Manuscript Illumination,* (New York: 1977), pls. 32–33.

Plate 28
P. Brieger, *English Art 1216–1307*, (Oxford: 1957), pp. 81–2, 177, pls. 21 a, c.
D.H. Turner, *Early Gothic Illuminated Manuscripts*, (London: 1965), p. 12, pl. 2.
Plate 29
Millar, *Chester Beatty*, II, (Oxford: 1930), pp. 70–5, pls. 123–26, colored frontispiece.
Brieger, *English Art*, pp. 221–22, pls. 82a, 87.
T.J. Brown, "The Salvin Horae," *British Museum Quarterly* XXI (1957–59): 8–12, pl. I.
Turner, *Early Gothic Manuscripts*, pp. 29–30, pl. 15.
Plate 30
Brieger, *English Art*, p. 224, pl. 86a.
Exhibited, *Art and the Courts*. National Gallery of Canada, (Ottawa: 1972), no. 26, pls. 40, 41.
Plate 31
D.D. Egbert, *The Tickhill Psalter and Related Manuscripts*, (New York: 1940).
Plate 32
Exhibited, *Art and the Courts*, no. 2, pls. 3, 4.
R. Branner, *Manuscript Painting in Paris during the Reign of Saint Louis*, (Berkeley: 1977), pp. 122ff., 236, figs. 365–66, 369, 377–78.
Plate 33
Millar, *Chester Beatty*, II, pp. 88–103, pls. 133–39.
D. Miner, "Since de Ricci—Western illuminated manuscripts acquired since 1934. A report in two parts: Part II," *Journal of the Walters Art Gallery* XXXI–II (1968–69): 62–8, figs. 15–19.
Plate 34
This manuscript does not appear to have been reproduced before. I owe knowledge of it to M.F. Avril.
L. Delisle, *Le Cabinet des manuscrits de la Bibliothèque impériale (nationale)*, I, (Paris: 1868), pp. 492–93.
E. van Moé, "Deux manuscrits de la bibliothèque de Benoit XII," *Bibliothèque de l'École de Chartes* CI (1940): 219–20.
Bibliothèque nationale. Catalogue général des manuscrits latins, V, (Paris: 1966), p. 262.
Plate 35
G. Schmidt, "Johann von Troppau und die vorromanische Buchmalerei," *Studien zur Buchmalerei und Goldschmiedekunst des Mittelalters. Festschrift für K.H. Usener*, ed. F. Dettweiler, H. Köllner, P.A. Riedl, (Marburg: 1967), pp. 275–92.
Gotik in Böhmen, ed. K.M. Swoboda, (Munich: 1969), pp. 119, 121, 213, pls. 132, 143; English edition: *Gothic Art in Bohemia*, ed. E. Bachmann, (London: 1977), pp. 49–50, pls. 132, 143.
J. Krasa, *Die Handschriften König Wenzels IV*, (Vienna: 1971), pp. 116–17, 136, 156, 269, pl. 78.
Plate 36
Giovannino de Grassi. Taccuino di disegni (Monumenta Bergomensia, V), intro. and facsimile. (Bergamo: 1961).
R.W. Scheller, *A Survey of Medieval Model Books*, (Haarlem: 1963), pp. 142–54.
A. Cadei, "Giovannino de Grassi nel taccuino di Bergamo," *Critica d' Arte* XVII (1970): 23–24.
U. Jenni, *Das Skizzenbuch der Internationalen Gotik in den Uffizien*, (Vienna: 1976), pp. 65–75, figs. 85, 89, 91.
Plate 37
P. Wescher, *Beschreibendes Verzeichnis der Miniaturen—Handschriften und Einzelblätter—der Kupferstichkabinetts der Staatliche Museen Berlin*, (Leipzig: 1931), pp. 108–9, pls. 98–9.
Exhibition Catalogue, *Medieval and Rennaissance Miniatures from the National Gallery of Art*, National Gallery of Art, (Washington: 1975), no. 21.
Exhibited, *Zimelien. Abendländische Handschriften des Mittelalters aus der Sammlungen der Stiftung Preussischer Kulturbesitz, Berlin-Dahlem*, (Wiesbaden: 1976), no. 145.
Plate 38
G.F. Warner, J.P. Gilson, *Catalogue of Western Manuscripts in the Old Royal and King's Collections*, III, (London: 1921), p. 9, pl. 123.
J. Wardorp, *The Script of Humanism. Some Aspects of Humanistic Script 1460–1560*, (Oxford: 1963), p. 51, pl. 34.
J.J.G. Alexander, A.C. de la Mare, *The Italian Manuscripts in the Library of Major J.R. Abbey*, (London: 1969), p. 109.
Plate 39
M.G. Ciardi-Dupré, *I Corali del Duomo di Siena*, (Siena: 1972), espec. p. 36, pl. 214.
Plate 40
J. van den Gheyn, *Catalogue des Manuscrits de la Bibliothèque Royale de Belgique, III. Théologie*, (Brussels: 1903), no. 2142.
Exhibited, *Le siècle d'or de la miniature Flamande. Le mécenat de Philippe le bon.* (Brussels, Amsterdam, Paris: 1959), no. 80, pl. 35.

List of Color Plates

XXI. Saint Bertin Gospels
New York, Pierpont Morgan Library, Ms. 333
96 fols. 326 x 208 mm.
Plate 21. Initial *Q* with the Annunciation to Zaccharias fol. 51

XXII. The Bible of Saint Vaast
Arras, Bibliothèque Municipale, Ms. 559, Volume III
155 fols. 495 x 365 mm.
Plate 22. Initial *Et.* fol. 52v

XXIII. The Figeac Sacramentary
Paris, Bibliothèque Nationale, Latin 2293
283 fols. 355 x 265 mm.
Plate 23. Initial *T.* fol. 19v

XXIV. Florus, Commentary on Saint Paul's Epistles
Paris, Bibliothèque Nationale, Latin 11575
144 fols. 475 x 340 mm.
Plate 24. Initial *P* with Saint Paul fol. 1

XXV. Josephus, Antiquitates Judaicae
Chantilly, Musée Condé, Ms. 1632
350 fols. 405 x 295 mm.
Plate 25. Initial *In* with Creation scenes fol. 3

XXVI. The Arnstein Bible
London, British Library, Harley 2799
243 fols. 544 x 362 mm.
Plate 26. *In principio* with Saint John fol. 185v

XXVII. Beatus, Commentary on the Apocalypse
Madrid, Biblioteca nacional, B.31
316 fols. 365 x 264 mm.
Plate 27. Initial *A* with Christ fol. 6

XXVIII. The Bible of Robert de Bello
London, British Library, Burney 3
513 fols. 268 x 198 mm.
Plate 28. Initial *I* with Creation scenes fol. 5v

XXIX. The Salvin Hours
London, British Library, Additional 48985
128 fols. 323 x 221 mm.
Plate 29. Initial *D* with the Tree of Jesse fol. 1v

XXX. The Windmill Psalter
New York, Pierpont Morgan Library, M. 102
168 fols. 322 x 220 mm.
Plate 30. Initial *E* with King Solomon fol. 2

XXXI. The Tickhill Psalter
New York Public Library, Spencer Collection 26
155 fols. 328 x 226 mm.
Plate 31. Initial *D* with King Saul fol. 26v

XXXII. Evangeliary of the Sainte Chapelle
Paris, Bibliothèque Nationale, Latin 17326
183 fols. 315 x 205 mm.
Plate 32. Initial *I* with scenes from the Life of Christ fol. 130v

XXXIII. The Beaupré Antiphonal
Baltimore, Walters Art Gallery, W. 759
223 fols. 490 x 345 mm.
Plate 33. Initial *A* with the Resurrection fol. 3v

XXXIV. Liber Soliloquiorum Animae Penitentis
Paris, Bibliothèque Nationale, Latin 3351
208 fols. 375 x 260 mm.
Plate 34. Initial *I.* fol. 121v

XXXV. The Gospel Book of John of Oppava
Vienna, Österreichische Nationalbibliothek, Cod. 1182
189 fols. 375 x 276 mm.
Plate 35. Initial *L.* fol. 2

XXXVI. The Sketchbook of Giovannino dei Grassi
Bergamo, Biblioteca Civica
31 fols. 260 x 185 mm.
Plate 36. Figure alphabet with letters *H* to *R* fol. 29v

XXXVII. Gradual
Berlin, Dahlem Museum, Kupferstichkabinett, 78.F.1
219 fols. 600 x 405 mm.
Plate 37. Initial *R* with the Resurrection fol. 1v

XXXVIII. Virgil, Works
London, British Library, Kings 24
245 fols. 283 x 180 mm.
Plate 38. Initial *Q.* fol. 17

XXXIX. Gradual
Siena Cathedral, Biblioteca Piccolomini, Cod. 23.8
120 fols. 835 x 580 mm.
Plate 39. Initial *R* with the Resurrection fol. 2

XL. Miroir de la Salvation Humaine
Brussels, Bibliothèque Royale, BR 9249–50
112 fols. 412 x 284 mm.
Plate 40. Initial *M.* fol. 1

List of Black & White Figures

38

Plates and Commentaries

PLATE 1

The Lindisfarne Gospels
fol. 95 *In. Opening of Saint Mark's Gospel*

The first three letters of the word *Initium* are combined here to form a monogram constructed with a typically Insular love of ambiguity. The *I* and the left upright of the *N* are joined by the balancing panels of pattern and the ornament at top and bottom. At the same time they are separated by the continuous narrow, uncolored band in the center, and by the alternation of plain and zoomorphic interlace in the panels. This alternation is made clearer by the color and contrasts of red and blue and red and green.

The design is made symmetrical by the similar construction of the right upright of the *N* and the second *I,* and this balancing vertical is then united to the first by the cross stroke of the *N,* which is filled with interlace running continuously from the panels at top and bottom, respectively. The design is also stabilized by the central cross which is again emphasized coloristically in red and blue.

Balance and unity on the page are achieved by the framing band on three sides which acts as a counterweight to the tall vertical shafts on the left. Finally, the space inside this frame is filled with more of the Gospel text. There is a gradual diminution of the size of the letters and also in the scale of their decoration, and the intervals between them are articulated with zoomorphic and interlace patterns made up of red dots.

The manuscript was written and probably also illuminated by Eadfrith, Bishop of Lindisfarne (698-721), in honor of his predecessor Saint Cuthbert (d. 687). In the later Middle Ages it was at Durham, and it came to the British Museum in 1753 with other manuscripts which had belonged to the antiquary, Sir Robert Cotton (d. 1631).

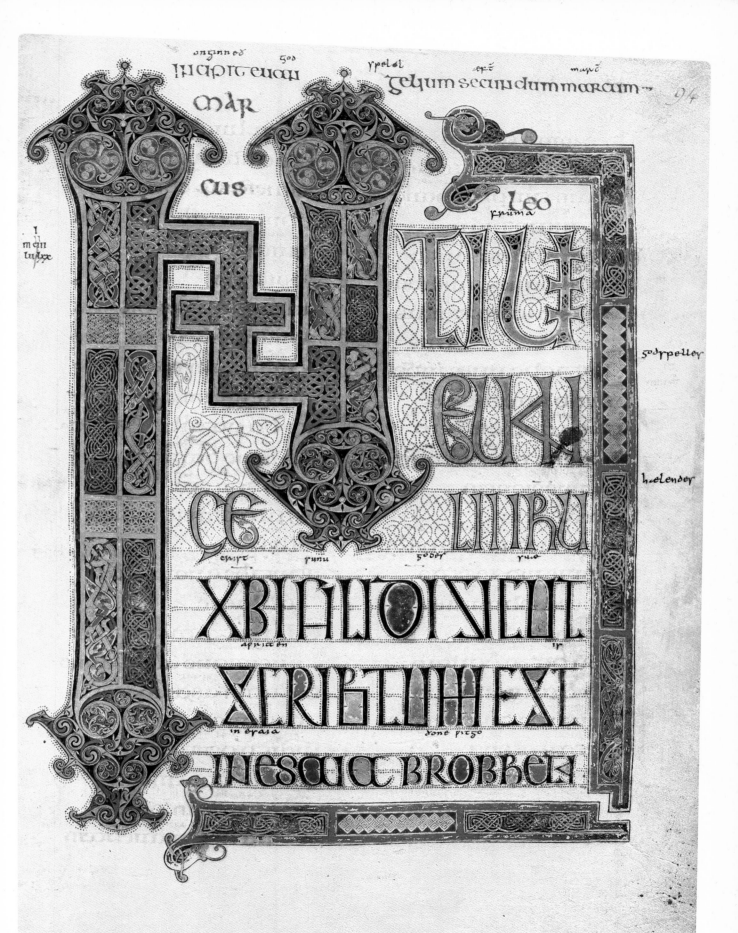

PLATE 2

THE BOOK OF KELLS
fol. 34 *Xpi. Opening of the Genealogy of Christ in
Saint Matthew's Gospel*

In scale and in the intricacy and richness of its decorative patterns, this page is unsurpassed in Insular illumination. Looking back to the small, uncolored initials of the *Cathach of Saint Columba* (Figure II), the amazing development upon the original idea of metamorphosizing the letter shape is apparent.

The tension between enclosing forms and what Wilhelm Koehler called the "kinetic" energy of Insular pattern is a feature of all Insular illumination, and nowhere more apparent than here. The letter shapes stand out from the confused mass of pattern by their purple or orange outline. The repeated circles which are like enameled escutcheons from hanging bowls, seem to revolve before our eyes, both continuing the curves of the X and being held in check by the letter form. The *L* shaped panel at the lower right corner also serves as a stabilizing frame, preventing the rioting patterns from exploding out of the page. Another constant of Insular art is the ambiguity of background and foreground. For example, the outer yellow band on the left of the *L* panel can be read either as a background upon which the irregularly shaped interlace panel is placed, or as a framing element of panels which are placed on top of the interlace.

In addition to the abstract patterning the manuscript contains, particularly on the text pages, numerous stylized but extremely lively representations of humans, animals, and birds. In this folio, small spaces are reserved for moths, cats and mice, and an otter eating a salmon. Natural observation finding a place in a sacred context, although in a subsidiary position, would become a feature of Gothic illumination (Plate 30).

The *Gospel Book* was preserved at Kells, County Meath, Ireland, from the twelfth century. When and where it was made have not been determined. It has been suggested that it was made in the late eighth century at Iona (founded off the west coast of Scotland by Saint Columba in 563), and brought to Kells by Irish monks when they fled from the Viking raiders in 804.

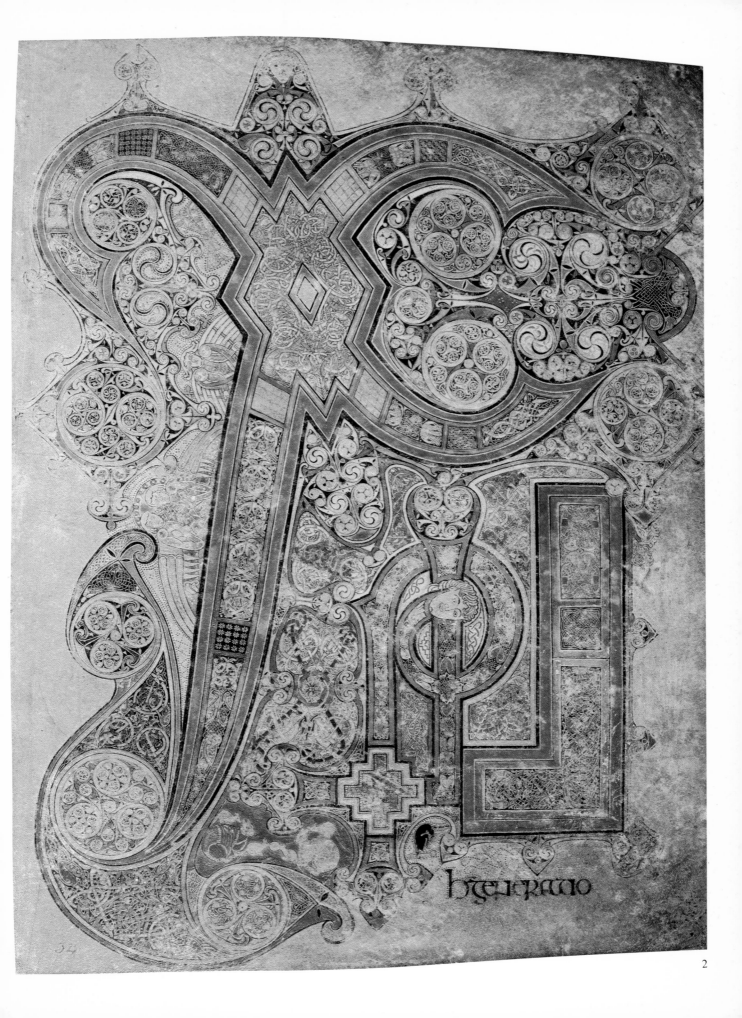

ẖGENERATIO

2

PLATE 3

SAINT AUGUSTINE, QUAESTIONES IN HEPTATEUCHON
fol. 1 *I. Title page*

The letters of the title of the work on this opening page are so varied in scale and so ornamented that it is hard to read them or tell where one word ends and another begins. The page is an interesting example of the combination of the vigor and movement of Insular illumination with the more static forms of Merovingian art. Thus the twisting beast to the left, at the bottom, can be contrasted with the two quadrupeds at the top of the page whose positions have the clarity of heraldic design. Other Insular features are the interlace, the black letters on the color-articulated backgrounds, and the biting beast heads as terminals. On the other hand, the use of limited colors in a contrasting mosaic- or enamel-like technique is typical of Merovingian manuscripts.

The manuscript is thought to have been written at Laon in the second half of the eighth century. It was at Corbie by the end of the century, however, since annotations were made there then. Like other Corbie manuscripts, it was sent for safety to Saint-Germain-des-Prés, Paris, in 1638 and thus, at the French Revolution, passed to the Bibliothèque Nationale.

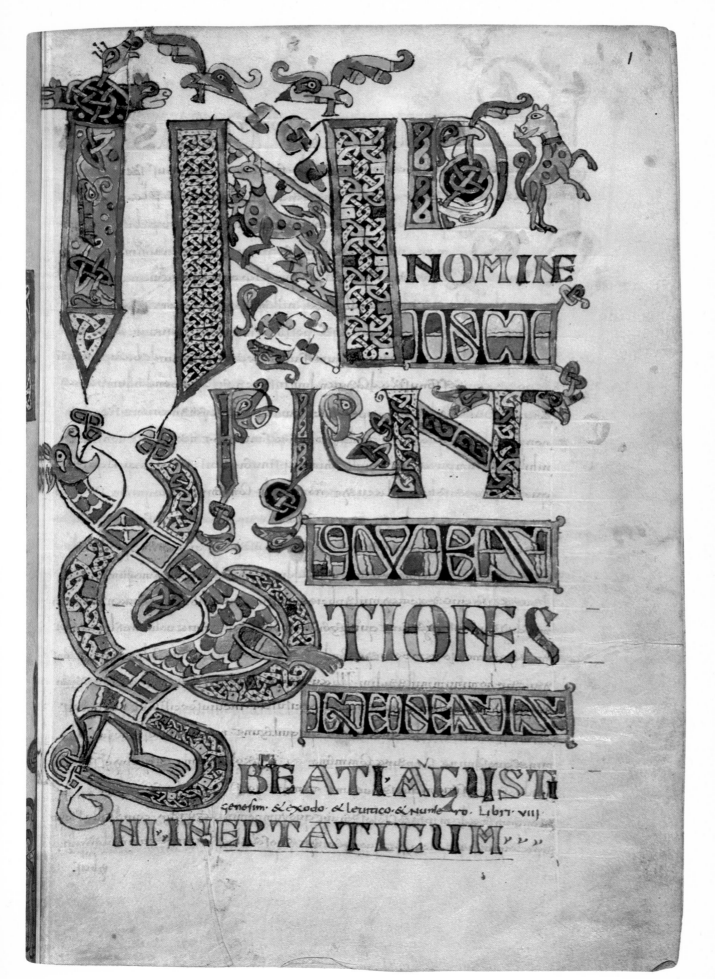

IN NOMINE DNI INCIPIVNT TOTIONES IN HEBTAM BEATI AGVSTI

genesim & exodo & leuitico & numero libri VIII

HII INEPTATICVM

1

3

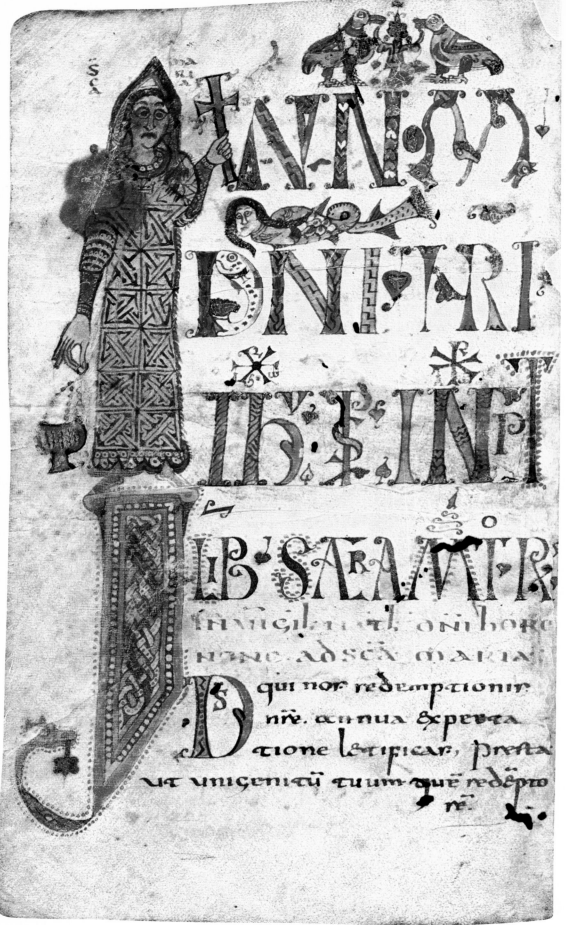

SCA

ANNS
DNI·TRI
IHS·✝·INI
LIB'SACVLF·
in uigiliis· dñi hora
nona ad sc̄a marin
Ds qui nos redemptionis
nr̄e. annua experta
ctione letificas, presta
ut unigenitū tuum quē redē pto
rē L·

4

PLATE 4

THE GELLONE SACRAMENTARY
fol. 1v *In nomine Domini. Mass for Christmas Eve*

The letters of the opening words, *In nomine Domini nostri Jesu Christi. Incipit liber sacra* (sic) *matris* are decorated with pattern and leaf forms. The two *I*s at the left are larger in size, however. The lower one is filled with interlace and surrounded with orange dots in the Insular manner. The upper one is formed of a human figure, identified by the inscription as the Virgin Mary, who carries in her right hand a censer and in her left a cross. Her presence is explained by the fact that this is the Mass of the Vigil of the Nativity.

The figure is frontal and the drapery becomes a flat pattern. Other initials in the manuscript, however, show figures in action, for example, a *D* showing the excavation of the True Cross (fol. 76v). The use of human figures as substitutes for the letter form rather than being attached to it or framed by it is an idea which began to appear in the eighth century and which, like the historiated initial (Figure III), has proven extremely fruitful—continuing to the end of the Middle Ages and even into our own time.

The *Sacramentary*, which is a primary authority for the history of the early Roman liturgy, is thought to have been written at the Benedictine Abbey of Meaux on the Marne in Northern France in the later eighth century. It later belonged to the Abbey of Gellone near Montpellier in Southern France from which it passed to the Maurists at Saint-Germain-des-Prés in the seventeenth century, and from there to the Bibliothèque Nationale in 1795.

PLATE 5

THE HARLEY GOSPELS
fol. 109 *Q. Opening of Saint Luke's Gospel*

This initial is historiated with the scene of the angel announcing to the priest Zaccharias the coming birth of his son, Saint John the Baptist (Luke 1:9–13). In roundels on either side of the bowl of the letter are bust figures identified as the Virgin Mary and Elizabeth, mother of the Baptist.

The *Gospel Book* is one of a group of sumptuous manuscripts produced under the patronage of the Emperor Charlemagne (d. 814), probably in a court scriptorium located at Aachen. The artists of this school had two main traditions to draw on. The first was that of the Insular manuscripts with their wealth of abstract pattern, especially on the initial pages. From this tradition came the interlace patterns, as well as the use of the historiated initial (Plate 1, Figure III). The second source was the Late Antique figurative and illusionistic tradition of Mediterranean art. From this came the other, more three-dimensional or organic patterns, the monumental Roman capitals in gold placed on purple panels, and such illusionistic details as the marbled columns. The iconography of the scene was also probably derived from a Mediterranean source, whether an ivory carving or a painting.

The Carolingian artist was not afraid of the inevitable contradictions inherent in the combination of the two traditions. For example, the deep space of the Annunciation scene with the Temple behind, is contradicted by the gold and purple ground which is linked to the flat bands of script below the letter. The artist rather used this tension to enliven his design with the echoing half-circles of the arch which frames the page, the bowl of the *Q*, the roof of the Temple, and its round, arched door.

The manuscript was bought by Robert Harley, Earl of Oxford, at the Hague in 1720 and was purchased by the British Museum with his manuscripts in 1753. Its earlier history is unknown.

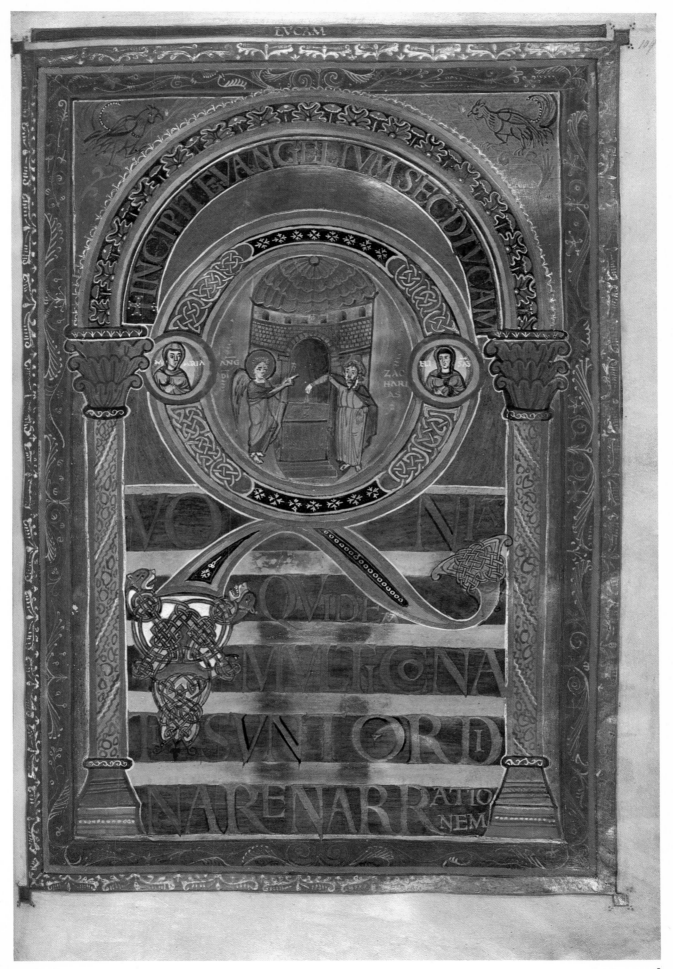

PLATE 6

THE DROGO SACRAMENTARY
fol. 58 *Ds. Mass for Easter Sunday*

A rich leaf scroll in gold twines around the letter *D* whose shape is also outlined in gold, but filled with a pale green neutral contrasting ground. At the top, the scroll spills over and falls down into the center of the letter, as if it were holding up the *S* (*Ds* is the abbreviation for *Deus*, God).

At the bottom, space is left for the scene of the three Marys who meet the Angel at the empty sepulcher on Easter morning (Mark 16:1–7). The tomb is shown, as on Late Antique ivories (e.g. Munich) and Carolingian copies of them, as a round cupola on a square base. The underdrawing is partly visible, from which it is clear that the scene was originally intended to be placed more to the right, with the soldiers below the tomb. Presumably it was changed to fit in better with the *S*. Two other episodes of Easter morning are shown in the bow of the *D:* Christ and Mary Magdalen (Mark 16:9), and Christ worshipped by the two Marys (Matt. 28:9).

Historiated initials only occur occasionally in other Carolingian manuscripts (Plate 5), but in this manuscript the illustration is entirely composed of them, and there are forty-one in all. The *Sacramentary* was made for Drogo, a natural son of Charlemagne — who became Bishop of Metz in 844 and died in 855 — since his name appears at the end of a list of Bishops of the See. It came to the Bibliothèque Nationale with other Metz manuscripts in 1802.

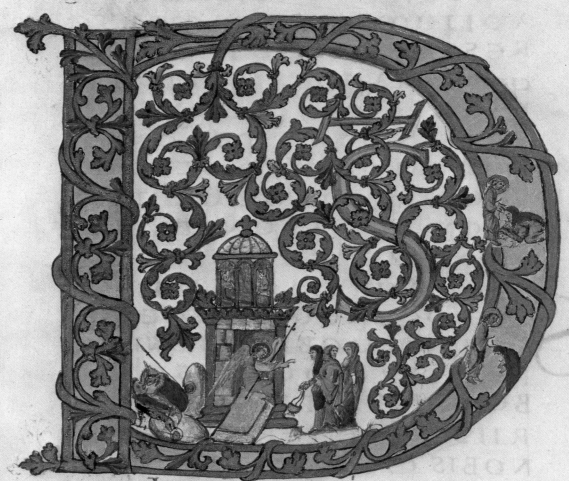

quihodiernadie
perunicenitutuu

PLATE 7

THE VIVIAN BIBLE (SO-CALLED "FIRST BIBLE")
OF CHARLES THE BALD
fol. 8 *D. Saint Jerome's Preface to the Pentateuch*

This page has a classical appearance typical of the products of the Carolingian *renovatio*. The words *Incipit praefatio Sancti Hieronimi presbiteri* are written in epigraphic Roman capitals in gold on purple panels, like an imperial inscription. The initial *D* contains representations of eleven signs of the Zodiac (Virgo and Libra are combined in one) with the twelfth sign, Pisces the Fish, in the center. They flank Sol the Sun, and Luna the Moon, each of whom drives a classical chariot and horses. The Zodiac signs and the Planets were represented in Late Antique astronomical and astrological treatises, especially the Latin translations of the Greek *Phainomena* of Aratus, and these were copied in various Carolingian manuscripts. Since the *D* introduces Saint Jerome's preface to the first five books of the Bible, perhaps some reference to the Creation of the Sun, Moon, and Stars as related in Genesis 1:16 is intended. Also classical in origin are the organic leaf scroll patterns and the bust-profile heads, which recall imperial coin types.

However, in other ways the page is very unclassical, with its obvious delight in rich ornamentation for its own sake. The frame with its irregular and varied patterns is not separated from the text, nor does it create an imaginary space, but is made to merge with the stem of the *D* to the left. Similarly, the imaginary space apparently provided in the *D* for the Sun and Moon is negated by the flanking Fish, and there is a *horror vacui* in the way the symmetrical framing lions, the medallion above the *D*, and the little leaf scroll terminals to the inscription panels are inserted in the empty spaces.

The *Bible* is the major production of the Abbey of Saint Martin at Tours. Three inscriptions record that it was dedicated to the Emperor Charles the Bald by the lay Abbot Count Vivian (844–51), and it was probably presented in 846 in a ceremony recorded in a miniature at the end of the book. It passed into the collection of Colbert, Louis XIV's finance minister, from the Cathedral of Metz (to which presumably it had been given by Charles the Bald), and entered the French Royal Library in 1732.

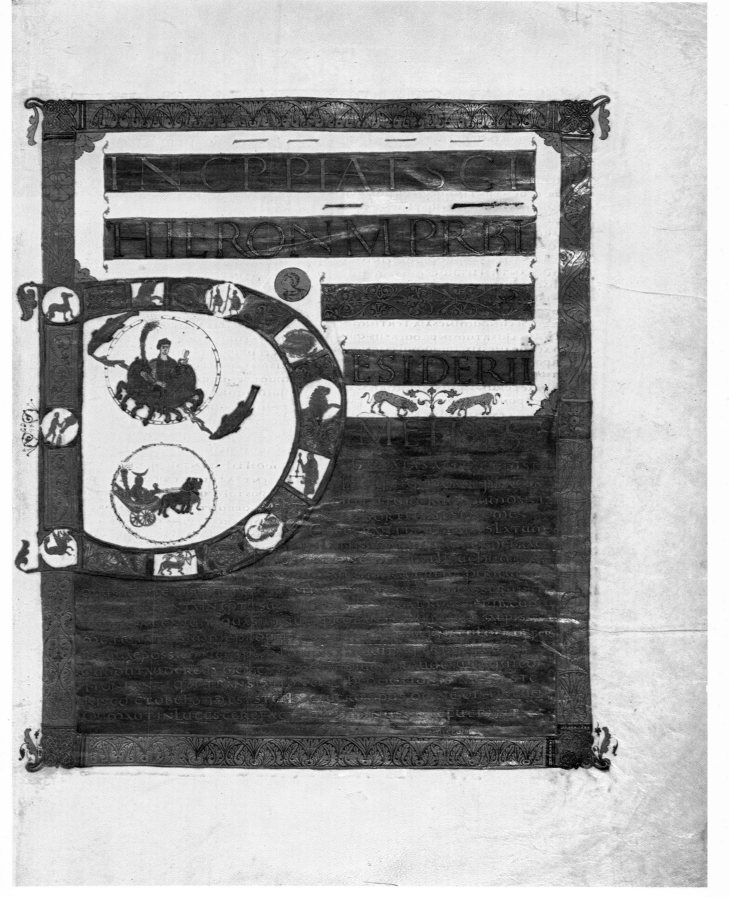

PLATE 8

GOSPEL BOOK
fol. 96 *Q. Opening of Saint Luke's Gospel*

The artist has achieved an effect of monumental grandeur by balancing simplified forms, above all the purple square set within the circle, and by limiting his colors to gold and purple with touches of violet, dark blue, and red. The plant scroll in the panels of the letter gives life to the design, but is strictly controlled. Inside the bowl of the letter the balancing scrolls are more or less symmetrical and direct the eye to the central point where the capital A is placed. The running scrolls within the letter shape, at the sides and below, are similarly balanced — with their simple blue-and-white, filling patterns — and controlled by the gold panels in which they are framed. The small leaves extending from the bowl of the Q are also symmetrical.

Notice also how the opening words, *Quoniam multi conati sunt ordinare,* contribute to the design — both the letters on the purple square with the A at the center, and those which balance the tail of the Q. The latter are not written on the ruled lines and the capitals in the last word *ordinare* diminish in size as does the tail of the Q.

The manuscript was written at Saint Martin at Tours, one of the leading scriptoria of the Carolingian Empire, which produced in the first half of the ninth century a series of *de luxe* manuscripts, particularly Bibles and Gospel Books (Plate 7). The date of the present manuscript is c. 857-62, according to Wilhelm Koehler. It came to the Pierpont Morgan library in 1952, having been in the collections of Henry Yates Thompson and Sir Alfred Chester Beatty.

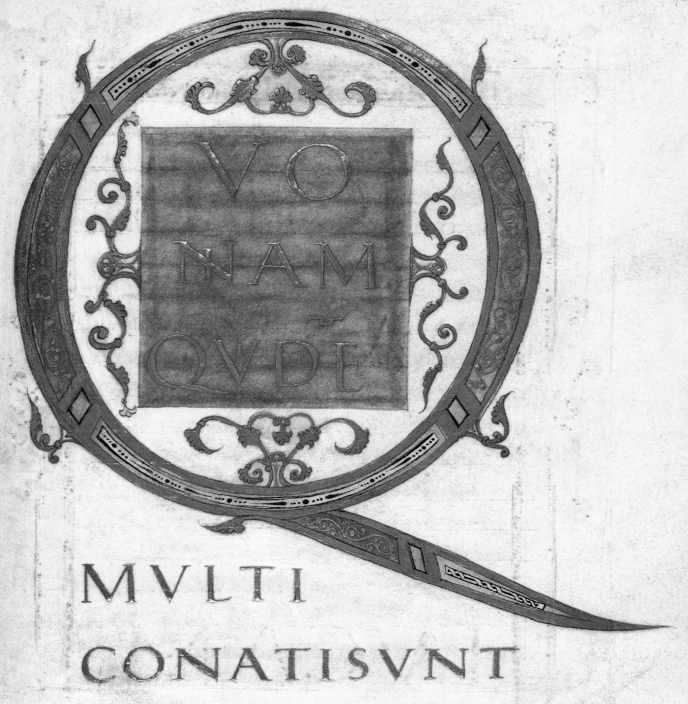

MVLTI

CONATISVNT

ORDINARE

PLATE 9

THE BIBLE (SO-CALLED "SECOND BIBLE")
OF CHARLES THE BALD
fol. 80 E. *Opening of the Book of Joshua*

In one of the Carolingian schools of illumination, the so-called Franco-Saxon school, the influence of Insular art predominated. Few of its manuscripts have figural scenes, and at first sight there are no signs of the influence of classical art in the decorative patterns used. However, there is a sense of monumental clarity and balance in many of the initial pages which, paradoxically, may be called classical. And the artists upheld the principle of the classical period whereby the letter forms remain clear and recognizable, in contrast to the way they are dissolved or fragmented in Insular or Merovingian manuscripts, or smothered in ornament as in the contemporary court school of Charles the Bald (Plate 10). On this page, the biting beast heads and the bird heads, the quadrupeds with interlacing tails, as well as the red dots outlining the letter and tracing a frame round it, are all Insular features, but used with a restraint not typical of Insular art (Plate 1).

A dedicatory poem states that the manuscript was made for the Emperor Charles the Bald (840–77) and it can be deduced that this was shortly after 871. It was no doubt written at Saint Amand in Northern France, as were a number of other manuscripts with similar decoration. Later, the Emperor evidently gave it to Saint Denis, near Paris, since it came from there to the French Royal Library in 1595.

INCI
PIT
LIBER
IESV
NAVE

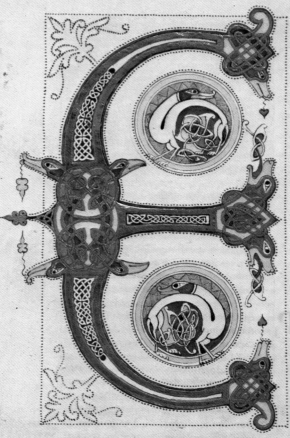

ET FACTUM EST UT POST
MORTEM MOYSIS SER
UI DÑI LOQUERETUR
DÑS AD IOSUE FILIÚ
NUN MINISTRÚ MOY
SI ET DICERET EI
MOYSES SERUUS ME
US MORTUUS E SUR
GE ET TRANSI IORDA
NEN ISTÚ TU ET OM
NIS POPULUS TECÚ
IN TERRAM QUÁ EGO
DABO FILIIS ISRAHEL

PLATE 10

THE CODEX AUREUS OF SAINT EMMERAM
fol. 17 *Liber. Opening of Saint Matthew's Gospel*

On this page the letters of the first verse of the Gospel *Liber generationis Jesu Christi, filii David, filii Abraham* are almost completely submerged by interlace and ornamental foliage which fill every space, and even twine around the letters to further obscure them. The letters of the word *Liber* are set above in diminishing size, and the remaining words are written in a block of three lines of similar-sized capitals. Something of the appearance of a monumental inscription is still preserved in spite of the ornament, and the artist also set the lettering apart by enclosing it in a series of framing bands. These graduate from acanthus and flat leaf-scroll patterns to a more illusionistic jeweled frame and, finally, to the aggressively three-dimensional meander pattern. The triangular "pediments" inserted on either side serve to focus the eye on the center of the page.

This *Gospel Book* is a product of the court school of the Emperor Charles the Bald, whose location is still uncertain. A dedicatory poem states it was written for the Emperor by the brothers Berengar and Liuthard in 870. It was later given to Saint Emmeram, Regensburg, by the Emperor Arnulf c. 893. The Bavarian monasteries were secularized in the early nineteenth century and the contents of their libraries transferred to Munich.

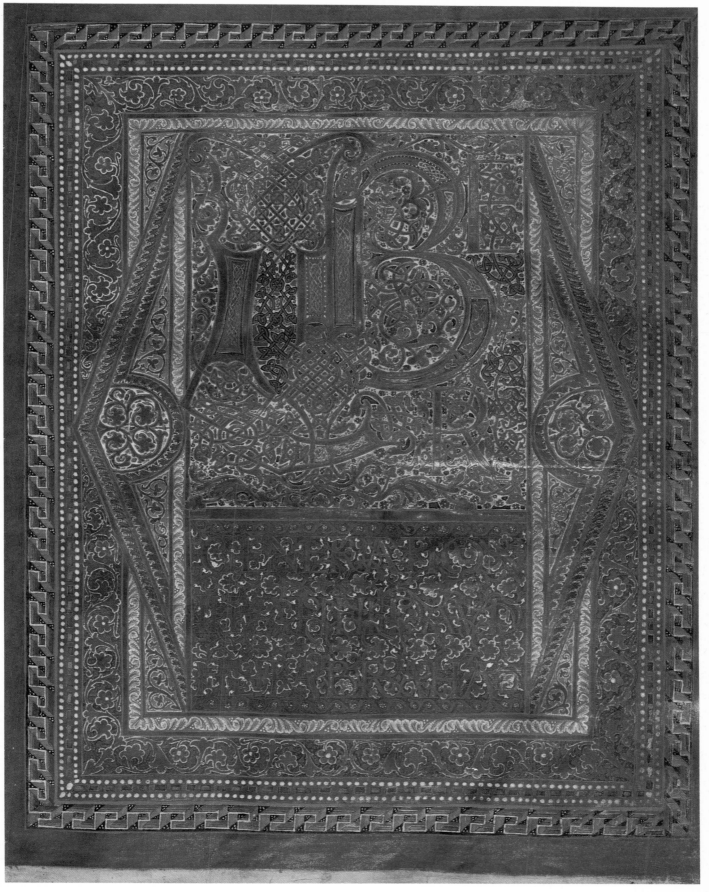

PLATE 11

THE PETERSHAUSEN SACRAMENTARY
fol. 106 *Ds. Mass for Easter*

This page is dominated by an initial *D* in its round, uncial form introducing the words *D(eu)s qui*. The artist has placed the letter under an arch ornamented with a fret pattern on silver and with gold interlace on the capitals and at the lower corners. He has ingeniously designed the interlace at the crown of the arch so that the tail of the letter merges with it; the letter thus seems to hang from the arch. The remaining letters *s qui* are in silver, and the gold interlace is on a silver background. This creates a series of layers, since the gold is laid over the silver and both are placed on a strongly patterned background, contrasting with the letter and serving to throw it forward. This way of representing space in a series of abstract layers, as it were, is typical of Ottonian art of the tenth and eleventh centuries and is seen equally in miniatures with figure scenes. It is interesting to contrast the letter on this folio with those created by Renaissance artists which are shown in perspective construction as if they had an actual three-dimensional existence (Plate 38). The initial is filled with a flattened abstract *rinceau* which was derived from later Carolingian manuscripts, especially those of Saint Gall.

The *Sacramentary* was at the Abbey of Petershausen near Minden in the twelfth century. It has a calendar for use at the great Monastery of Reichenau on Lake Constance and has often been thought to have been produced there. However, the calendar is in a different script and seems not to have originally belonged to the manuscript which may, therefore, have been made elsewhere. The probable date is c. 950–70.

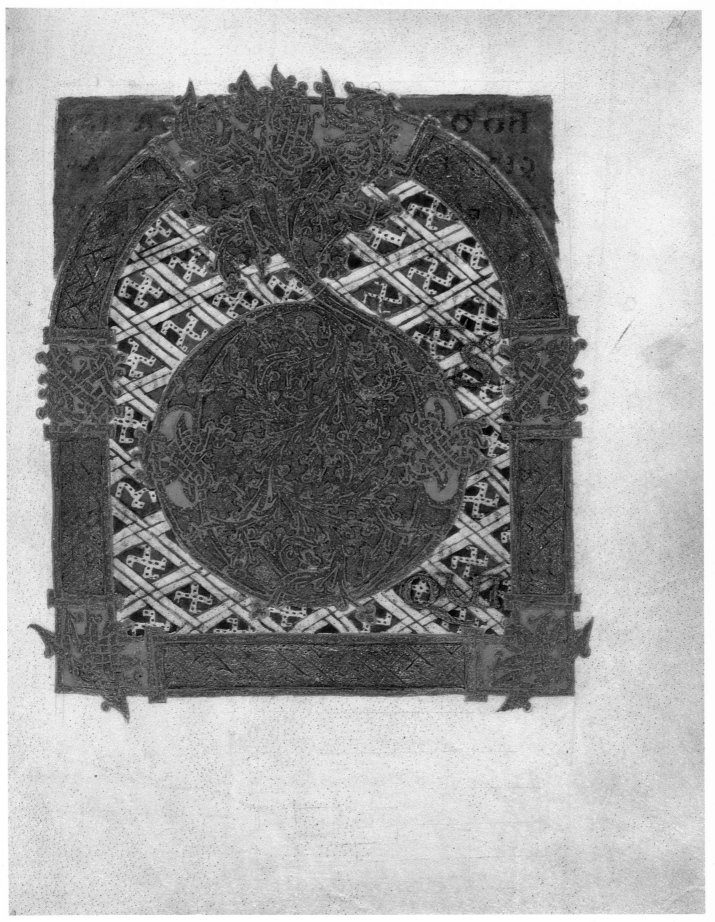

PLATE 12

THE TRIER GOSPELS
fol. 16 *Li. Opening of Saint Matthew's Gospel*

The form of the capital *L* is articulated by three interlace knots, and the *I* is interlaced with its horizontal panel below. The stems of the leaf scroll on either side of the *I* also interlace with the vertical of the letter, and the two capitals and the scroll are thus united. At the same time the separate identity of the letters is made clear by the panels of interlace in white contained in the verticals and the horizontal bar of the *L*. The letters are placed on a purple ground and the remaining letters *(Li)ber generationis* in gold are fitted around them. They overlap the first two framing bands which are in pink and gold.

The four corners of the frame are emphasized by projecting scrollwork terminals and by acanthus motifs in a contrasting color, dark blue. The center of each side is also marked by a square frame in blue upon which is placed a gold disc with a bust figure like a coin, each with an inscription including the words *Otto Imperator*. The whole page gives the impression of a series of flat, overlapping planes of which the letters *Li* and the coin medallions are the uppermost, and this is typical of Ottonian artists' spatial constructions (Plate 11).

The illumination is by the great artist known after his most famous work, a representation of Pope Gregory the Great, as the "Master of the Registrum Gregorii." It was probably executed at Trier after 996, since the coin medallions seem to refer to the Coronation of Otto III as Emperor in that year. Carl Nordenfalk has analyzed the classical tendencies of this Master's work, well shown here in the ordered and rhythmic balance of the foliage scroll.

The *Gospel Book* was evidently at Cologne in the eleventh century since it was copied there several times. Later, it belonged to Canon Johannes Laer—who may have gotten it from Gernesheim, and who gave it to the Jesuit College in Düsseldorf. It was bought by Andrew Fountaine in 1855 from the Bollandists in Brussels. In 1894 it was bought by the 26th Earl of Crawford and Balcarres, and was acquired with other Crawford manuscripts by Mrs. Rylands for the newly founded John Rylands Library in 1901.

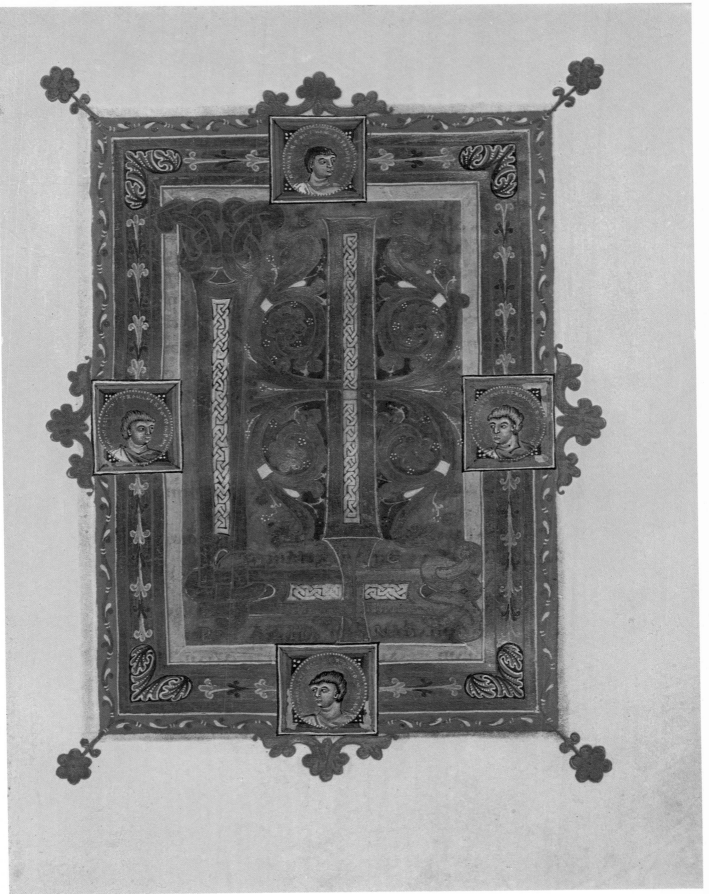

PLATE 13

COMMENTARY ON DANIEL
fol. 32 A. *Opening of the Book of Daniel*

The initial A is silhouetted on plain parchment under an arch set on a purple ground and framed. A node scroll in the center forms the crossbar of the letter and extends above. Here the prophet sits amidst the entwining scroll, writing his book at the inspiration of the angel. Historiated initials are not very common in Ottonian manuscripts and the explanation here seems to be that Daniel is to be thought of as witness of the main scene represented on the opposite page: Nebuchadnezzar's dream.

The manuscript belongs to the so-called Liuthar group of finely illuminated Ottonian manuscripts which may have been made at the Monastery of Reichenau on Lake Constance for the Emperor Otto III (d. 1002). It was later given to the newly founded Cathedral of Bamberg by the Emperor Henry II (1002–24).

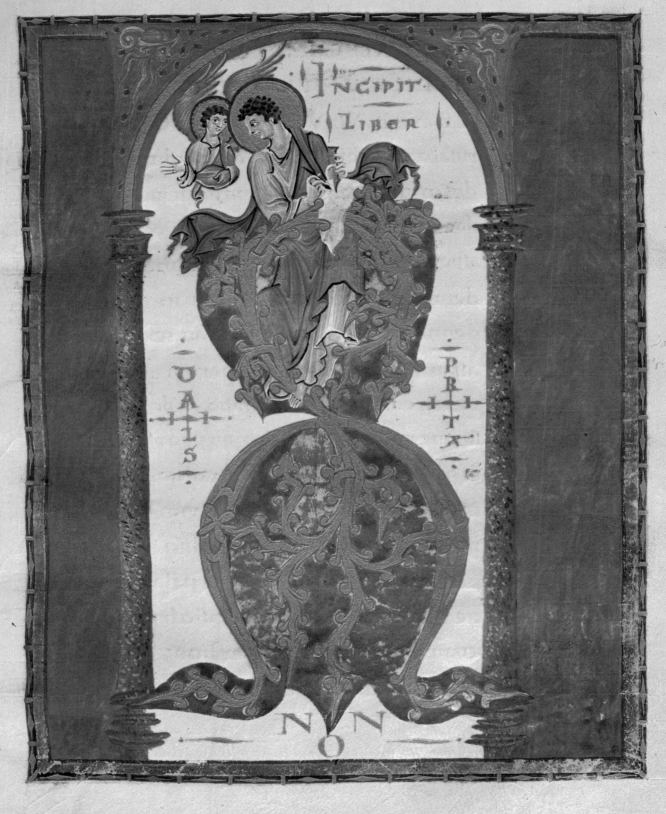

PLATE 14

PERICOPE BOOK
fol. 41 *I. Gospel Reading for Easter Saturday*

The *I* is shown as if it were a tree trunk up which the little man climbs, using the small protruding nodes as supports. Although figures climbing trees are represented in various scenes of Christian art, for example in the Entry to Jerusalem or in the story of Zacchaeus who climbed a tree to see Jesus pass, it does not seem that there is any narrative meaning here. Possibly the letter may have been thought of as symbolic of the soul's upward journey, but it seems more likely that it is simply a product of the artist's fantasy and humor. We encounter the same problem of meaning in many Romanesque initials in which there are similar motifs of struggle or combat (Figure XI). The manuscript is a late member of the so-called Liuthar group of finely illuminated manuscripts and was perhaps produced at the Monastery of Reichenau on Lake Constance in the early eleventh century (Plate 13). Its early history is unknown. It was acquired by Herzog August the Younger of Brunswick, Lüneburg, Wolfenbüttel, c. 1655–65.

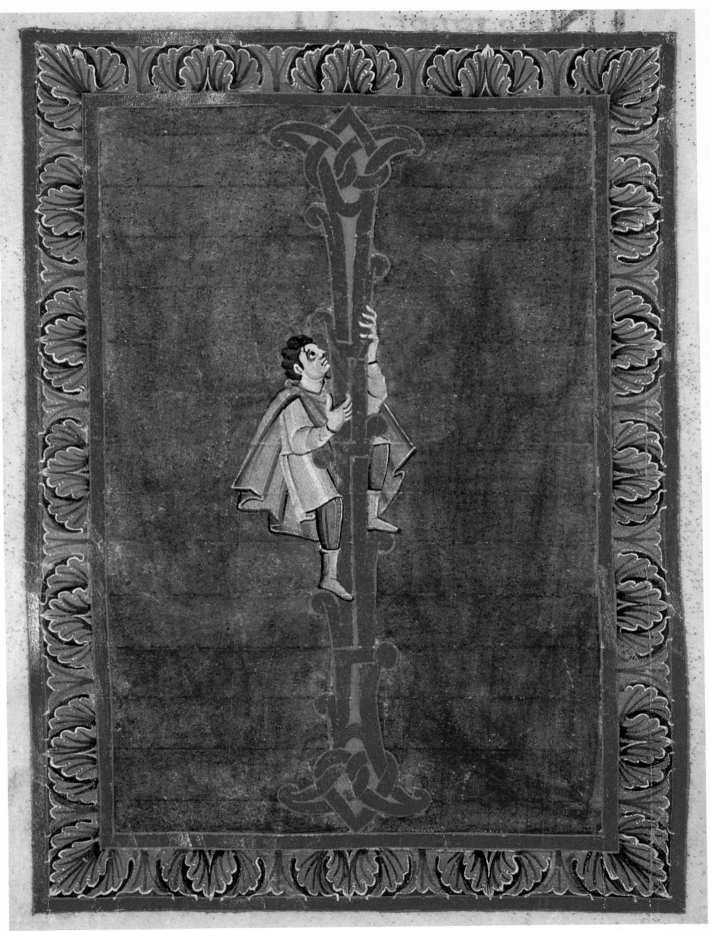

14

PLATE 15

THE HARLEY PSALTER
fol. 4 B. *Psalm 1*

This is the initial B of the first verse of the *Psalter, Beatus vir,* "Blessed is the Man." The form of the capital with its interlace and bird-beak terminals and panels-framing acanthus is derived from Carolingian Franco-Saxon initials (Plate 9). The type of organic foliage with its turning three-dimensional leaves and the hollowed clasping nodes of the stem does not occur in Carolingian manuscripts and is also in complete contrast to the flat, abstract scrollwork of contemporary Ottonian manuscripts (Plates 11–14). It was developed from earlier Anglo-Saxon manuscripts such as the *Junius Psalter* (Figure VIII), and its ultimate origin was probably Eastern Mediterranean.

The artist thus combined the letter form and scroll from different sources, so that he set up a tension between the legible, firmly outlined architectonic shape of the B, and the liveliness and movement of the foliage. The balancing circular, turning movement outwards from the central lion mask echoes and strengthens the curves of the bowl of the letter. At a few points the scroll passes below or above, or grips the frame like a vine on a trellis, which further gives the effect of the letter being a containing and supporting structure (Plate 6).

This type of letter with foliage scroll—which later came to be inhabited by birds, animals, and humans — was soon copied in numerous Northern French and Norman scriptoria, and this particular design for the letter B in which the lion mask holds the whole composition together in a relentless grip, was copied literally in a number of later Anglo-Saxon, Norman, and Anglo-Norman manuscripts (Figure X).

Textual and paleographical evidence suggests that the *Psalter* was written at Winchester Cathedral Priory, c. 980. It was acquired for the British Museum in 1753 with other manuscripts collected by Robert Harley, Earl of Oxford (d. 1724).

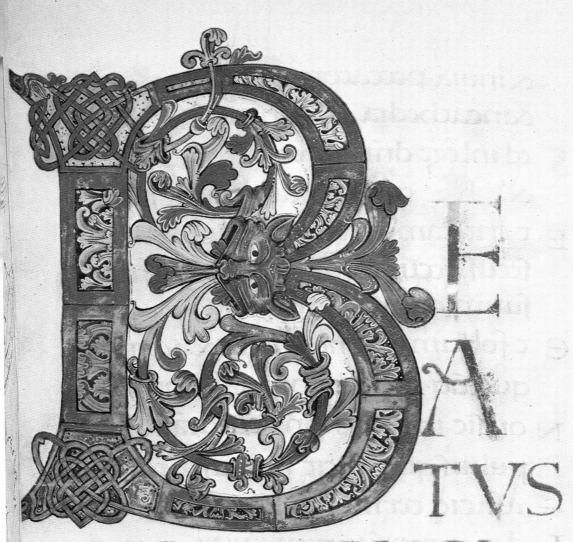

BE
A
TVS

VIR QVI NON
ABIIT IN CON
SILIOIMPIORVM

PLATE 16

THE ARUNDEL PSALTER
fol. 93 D. *Psalm 109*

This initial introduces the verse *Domine exaudi orationem meam,* "O Lord hear my prayer." It is historiated with the scene of the shepherd boy David cutting off the giant Goliath's head (I Samuel 17:23–51). The *Vespasian Psalter* from Canterbury (Figure III), has two historiated initials with scenes from the life of David, so that the artist here followed an already ancient tradition. David, who was armed only with a sling, had to cut off Goliath's head with the Philistine champion's own sword.

The *D* is reminiscent of Carolingian Franco-Saxon school initials in design (Plate 9). The other words of the verse are written in mixed capitals diminishing in size and in different colored inks contrasting with the blank parchment, giving life to the page. The gold-bar frame is ornamented with acanthus and three-dimensional foliage motifs. The colors of the acanthus in the panels are counterchanged above and to the sides.

Entries in the calendar show that the *Psalter* was written at Christ Church Cathedral Priory, Canterbury, c. 1012–23. The script can also be attributed to a leading Canterbury scribe, Eadvius Basan, who signed a *Gospel Book* now in Hannover, and who may also have been responsible for the illumination. A note records that the *Psalter* was given to a Canterbury monk, John Waltham, by William Hadly, Sub-Prior from 1471–99. It belonged to William Howard in 1592 and passed to his nephew, Thomas Howard, Earl of Arundel. It was acquired by the British Museum with other Arundel manuscripts in 1831.

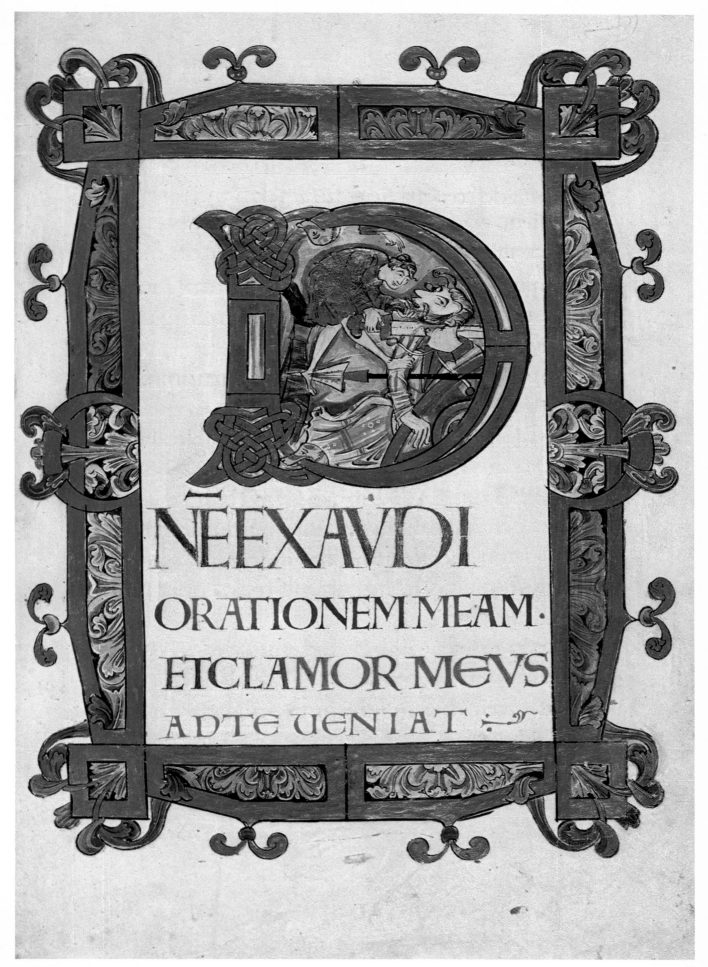

NE EXAVDI
ORATIONEM MEAM·
ETCLAMOR MEVS
AD TE VENIAT

16

PLATE 17

CALENDAR
fols. 3v (A), 4(B), 6 (C), 7 (D) *KL monograms*

During the Carolingian period the months of the year began to be represented by their appropriate activities such as harvesting or pruning the vines, rather than as personifications holding attributes as in classical art. Two early eleventh century Anglo-Saxon calendars also contain representations of the Occupations of the Months. It was not until the Romanesque period, however, that it became common to illustrate liturgical calendars, that is, lists of church feasts and Saints' days throughout the year, with scenes of the Occupations of the Months and Signs of the Zodiac.

The *KL* monogram standing for *Kalendae,* the first day of the Roman month, was often decorated earlier, but here the monogram and the Occupation are combined to make a series of historiated initials. For May, a man with a hawk whose red jesses hang below his wrist, is shown; for June, a man shearing a sheep; for October, a man knocking down acorns to feed pigs; and for December, a man feasting at table and holding up a bowl and a drinking horn. In each month the *KL* is partly formed of a foliage scroll, and often the men appear to sit on the crossbar of the monogram. A darker background silhouettes the letters and the figures, making a stage against which the latter perform their tasks.

The *Calendar,* a fragment of eight folios, was probably written at Saint Albans Abbey c. 1140 and then bound with a mid-twelfth-century *Psalter* at Winchester c. 1200. In the thirteenth century the whole manuscript belonged to Adam Basset of Littlemore, near Oxford, and in the fifteenth century to Littlemore Nunnery. It reached the Bodleian Library as the gift of Richard Beswick, a Fellow of Exeter College, Oxford, c. 1672.

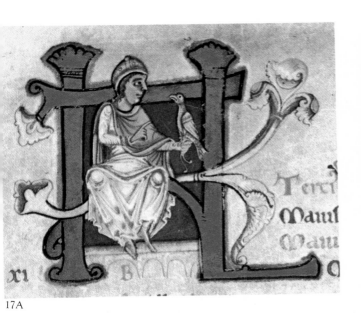

17A

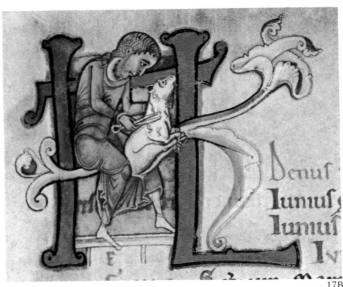

17B

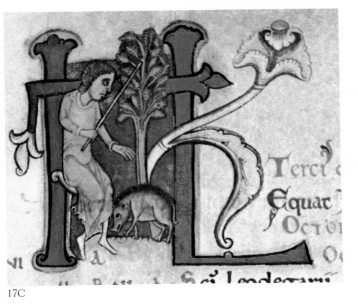

17C

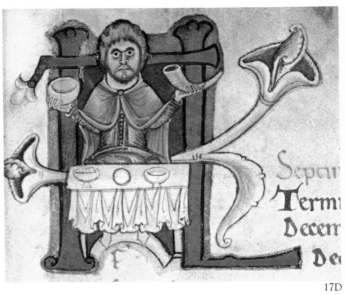

17D

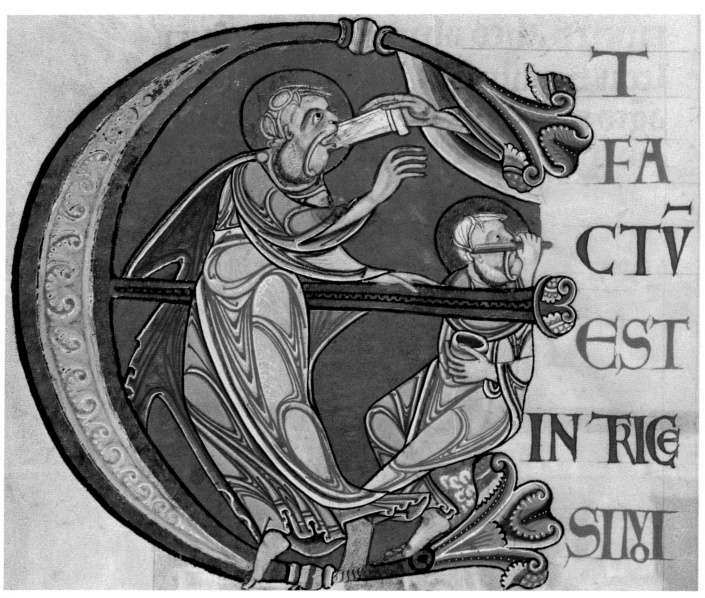

T
FA
CTŪ
EST
IN TICE
SIM

PLATE 18

THE LAMBETH BIBLE
fol. 258v *E. Opening of the Book of Ezekiel*

The scene represents God's command to Ezekiel: "Son of Man, eat this roll and go speak unto the house of Israel. . . . Then did I eat it and it was in my mouth as honey for sweetness" (Ezekiel 3:1–4). Later God commands the prophet: "Take thee a barber's razor and cause it to pass upon thine head and upon thy beard" (Ezekiel 5:1). It is made clear that the figure of Ezekiel is repeated since the robes of both figures in the initial are the same color.

The shape of the initial is outlined in gold with colored leaf terminals. From the one above, the Hand of God extends and Ezekiel, represented for the second time, seems to use the lower one as a seat. The larger figure of Ezekiel stands on tiptoe and swivels in a prophetic frenzy to eat and inwardly digest the Lord's word, steadying himself with a hand on the crossbar of the letter. Both figures are silhouetted against a bright blue background. The decorative display script in mixed capitals is written in alternate lines of red and blue and provides a transition from the initial to the script.

The *Lambeth Bible* is Volume I of a two-volume *Bible* of which the second volume is in Maidstone Museum, Kent. It contains the name of John Colyer of Lenham near Maidstone, with the date 1538, and it seems likely that he acquired it from the Abbey of Saint Augustine's, Canterbury, which was dissolved by King Henry VIII in that year. The Lambeth Palace Library volume was given by Archbishop Bancroft in his foundation bequest of 1610. The artist of the *Bible*, who may have been a professional lay illuminator and not a monk, also worked on the Continent, since he illuminated a *Gospel Book* for Abbot Wedric of Liessies in Hainault in 1146. This gives an approximate date for the making of the *Bible*.

PLATE 19

THE WINCHESTER BIBLE
A) fol. 120v *P. Opening of the Second Book of Kings*
B) fol. 190 *A. Opening of the Book of Daniel*

This *Bible* was written at Winchester in the mid-twelfth-century and, like the *Lambeth Bible*, contains historiated or decorated initials to each book and some full-page miniatures. A number of artists worked on the *Bible* over a period of perhaps thirty years, and the illumination was never completed, so that many initials are only uncolored drawings. The artist of the *P* has been named by Dr. Oakeshott the "Master of the Leaping Figures." His drapery is a less stylized version of the "damp fold" conventions seen in the *Lambeth Bible* (Plate 18), and his work falls in the period c. 1115–60. The artist of the *A* is named the "Master of the Morgan Leaf" after a detached folio in New York. He often painted over designs by earlier illuminators, but his style is calmer and more classical. He has been shown to have had first-hand knowledge of the Byzantine mosaics in Sicily, and was probably working in the 1170s.

Both artists fit narrative scenes into the initials with great ingenuity. In the bowl of the *P* the prophet Elijah rebukes the messengers of King Ahaziah and foretells the King's death (II Kings 1:1–8). Beneath, Elijah is carried up to heaven in the fiery chariot with his mantle falling below to be caught by his disciple, Elisha (II Kings 2:11–14). The letter provides a stage against which the scene is played out, and its shape controls the figures' poses. Above, the furious prophet, described in the text as a hairy man (!), echoes the upright of the letter, and the messengers recoiling from his stabbing finger are bent to fit the curving bowl. Below, the yellow cloak falling down in the center emphasizes, by contrast, the upward movement of the chariot. In the *A*, Belshazzar's feast is probably shown (Daniel 5), although the hand writing the inscription is absent. Here the initial frames the scene, but the two coalesce in that the table forms the crossbar of the letter.

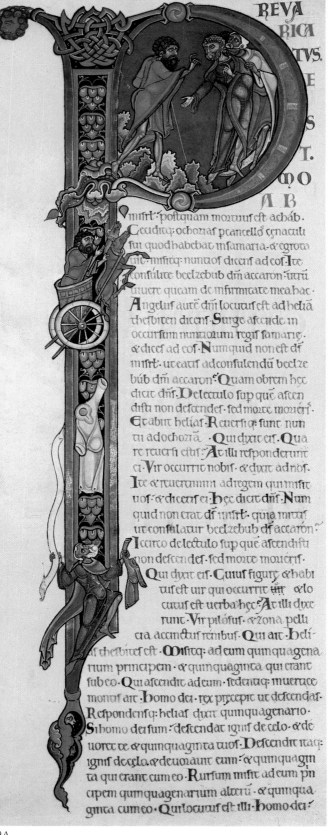

misit. postquam mortuus est achab.
Ceciditq; ochozias pcancello cenaculi
sui quod habebat insamaria. & egrota
uit misitq; nuntios dicens ad eos. Ite
consulite beelzebub dm accaron. utru
uiuere queam de infirmitate mea hac.
Angelus aute dni locutus est ad helia
thesbiten dicens. Surge ascende in
occursum nuntiorum regis samarie.
& dices ad eos. Numquid non est ds
misit. ut eatis ad consulendu beelze
bub dm accaron? Quam obrem hec
dicit dns. De lectulo sup que ascen
disti non descendes. sed morte morieris.
Et abiit helias. Reuersiq; sunt nun
tii ad ochoziam. Qui dixit eis. Qua
re reuersi estis? At illi responderunt
ei. Vir occurrit nobis. & dixit ad nos.
Ite & reuertimini ad regem qui misit
uos. & dicetis ei. Hec dicit dns. Num
quid non erat ds inisrl. quia mittis
ut consulatur beelzebub ds accaron?
Icirco de lectulo sup que ascendisti
non descendes. sed morte morieris.

Qui dixit eis. Cuius figure & habi
tus est uir qui occurrit uob. & lo
cutus est uerba hec? At illi dixe
runt. Vir pilosus. & zona pelli
cia accinctus renibus. Qui ait. Heli
as thesbites est. Misitq; ad eum quinquagena
rium principem. & quinquaginta qui erant
sub eo. Qui ascendit ad eum. sedensq; inuertice
montis ait. Homo dei. rex precepit ut descendas.
Respondensq; helias dixit quinquagenario.
Si homo dei sum. descendat ignis de celo. & de
uoret te & quinquaginta tuos. Descendit itaq;
ignis de celo. & deuorauit eum. & quinquagin
ta qui erant cum eo. Rursum misit ad eum pn
cipem quinquagenarium alterum. & quinqua
ginta cum eo. Qui locutus est illi. Homo dei

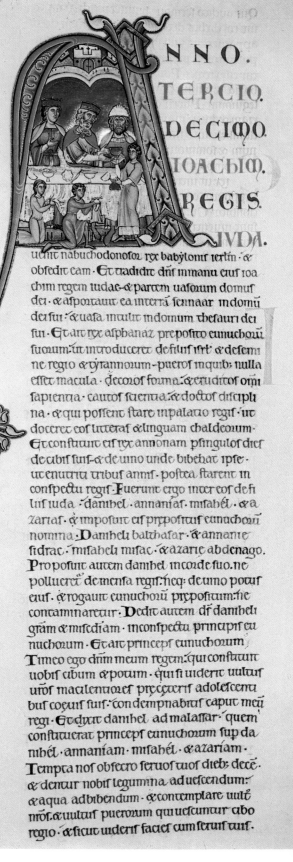

NNO.
TERCIO.
DECIMO.
IOACHIM.
REGIS.
IVDA.

uenit nabuchodonosor rex babylonis ierlm. &
obsedit eam. Et tradidit dns inmanu eius ioa
chim regem iudae. & partem uasorum domus
dei. & asportauit ea interra sennaar indomu
dei sui. & uasa intulit indomum thesauri dei
sui. Et ait rex asphanaz preposito eunuchoru
suorum. ut introduceret de filiis isrl. & de semi
ne regio & tyrannorum. pueros inquib; nulla
esset macula. decoros forma. & eruditos omi
sapientia. cautos scientia. & doctos discipli
na. & qui possent stare inpalatio regis. ut
doceret eos litteras & linguam chaldeorum.
Et constituit eis rex annonam psingulos dies
de cibis suis. & de uino unde bibebat ipse.
ut enutriti tribus annis. postea starent in
conspectu regis. Fuerunt ergo inter eos de fi
liis iuda. daniel. ananias. misahel. & a
zarias. & imposuit eis prepositus eunuchoru
nomina. Danieli balthasar. & ananie
sidrac. misaheli misac. & azarie abdenago.
Proposuit autem daniel incorde suo. ne
polluerer de mensa regis. neq; de uino potus
eius. & rogauit eunuchoru prepositum. ne
contaminaretur. Dedit autem ds danieli
gram & misdiam. inconspectu principis eu
nuchorum. Et ait princeps eunuchorum.
Timeo ego dnm meum regem. qui constituit
uobis cibum & potum. qui si uiderit uultus
uros macilentiores preceteris adolescenti
bus coeuis suis. condempnabitis caput meu
regi. Et dixit daniel ad malassar. quem
constituerat princeps eunuchorum sup da
nihel. ananiam. misahel. & azariam.
Tempta nos obsecro seruos tuos diebz dece
& dentur nobis legumina ad uescendum.
& aqua adbibendum. & contemplare uult
nros. & uultus puerorum qui uescuntur abo
regio. & sicut uideris facies cum seruis tuis.

PLATE 20

THE MUNICH PSALTER
fol. 31 B. *Psalm 1*

This initial is still of basically the same design as the *B* introducing Psalm I in the *Harley Psalter* of two centuries earlier (Plate 15). However, the letter together with the capitals of the rest of the first word of the first verse, *(B)eatus,* are placed on a diapered background and framed. The stems of the leaf scroll have also become very thin and wiry, and there is no longer the distinction between scroll and letter form, since the two seem to merge. The stems of the scroll form a series of concentric circles interlaced with each other. In the centers of the circles at the perimeter of each group are large flamboyant blossoms with curling petals which grip the stems and which are of a type that developed in English manuscripts from the second quarter of the twelfth century. The small white lions in the scroll also occur in many manuscripts of the period, especially glossed books (Figure XIX).

In an earlier Norman *B*, episodes from the life of King David were inserted in the initial and then enmeshed in the plant scroll (Figure X). Here they are shown unencumbered in the four corner roundels on a gold ground: David rescuing the Lamb from the Lion, David killing the Lion, David fighting Goliath, and Samuel annointing David. The two Kings in the half roundels at the sides are David playing the harp and, probably, his son Solomon.

This is one of a group of Psalters which has extended cycles of miniatures with similar iconography. It has been suggested that the group could have been made at Oxford before and after 1200. The *Psalter* is thus a transitional work between the Romanesque and Gothic styles, and the grill-like spirals of the letter already announce the transparent spatial constructions of the later period (Plate 30).

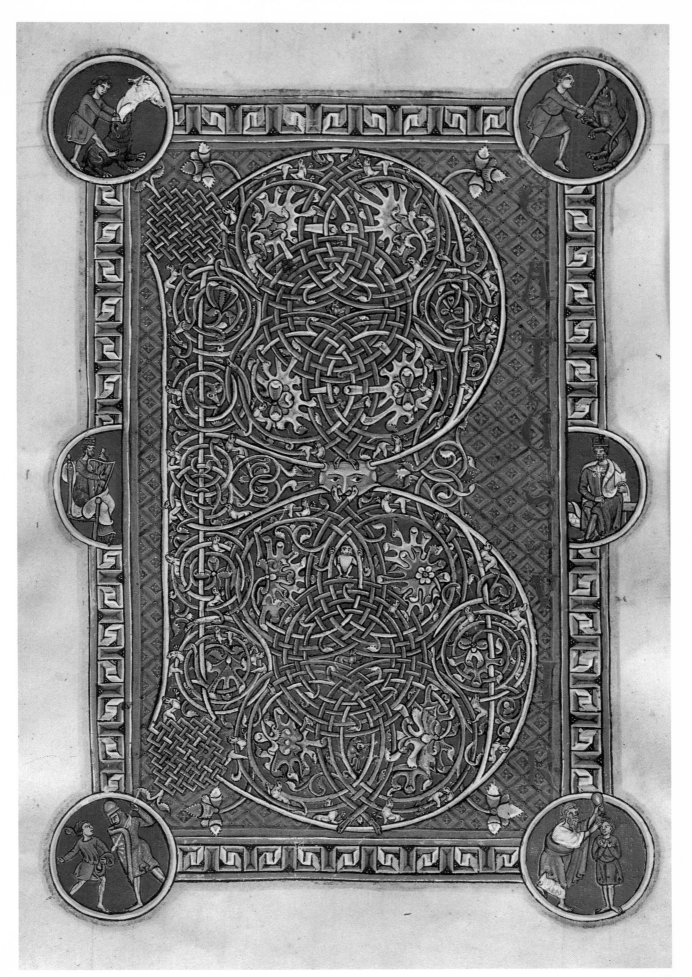

PLATE 21

Saint Bertin Gospels
fol. 51 *Q. Opening of Saint Luke's Gospel*

The initial is placed on a recto opposite an Evangelist portrait on the preceding verso. The frame and the initial are outlined in powdered gold and to add to the splendor of the opening, the text on this page is written in gold on purple. There is a subtle touch in the way the gold bars of the inner frame surrounding the purple panel overlap the squares at the corners, so that the purple panel appears to be placed on top of, rather than enclosed by, the outer panels of the inhabited scroll. These panels show hunting scenes at top and bottom, and a scroll with lions, birds, and dragons to each side. Such motifs became very common in Romanesque art and are probably purely decorative and without meaning. Six medallions have female personifications labeled Letitia, Victoria, and Lux on the left, and Caritas, Gaudium, and Vita on the right.

The shape of the *Q* is filled with another scroll. The main scene in the bowl of the letter is the Annunciation to the prophet Zaccharias by the Angel of the coming birth of his son, Saint John the Baptist. The same scene in the same context is shown in the Carolingian *Harley Gospels* (Plate 5). The figures are enlarged and molded by their setting, bending forward to conform to the letter shape in a way typical of Romanesque art. In the tail of the *Q* is the Nativity of Christ, and to the left a small figure of a prostrate, worshiping monk.

This monk is no doubt Otbert, Abbot of Saint Bertin. In the *Psalter* of Saint Bertin (Boulogne-sur-mer, Ms. 20) a poem states that the manuscript was written by Heriveus and illuminated by Otbert (Abbot c. 968–1007). His style is easily recognizable, and the miniatures in the *Gospel Book* are certainly by his hand. Saint Bertin manuscripts of this period are influenced by earlier Carolingian and contemporary Anglo-Saxon illumination, especially that of the Canterbury monasteries across the Channel. The former is clear here in the Franco-Saxon type of initial (Plate 9), and the latter in the figure and drapery style and in the inhabited scrolls (Plates 15–16). The manuscript was at Beauvais Cathedral until some time late in the nineteenth century. It was acquired by J. Pierpont Morgan in 1907.

MVLTI
CONATISVNT
ORDINARE
NARRATIONEM

21

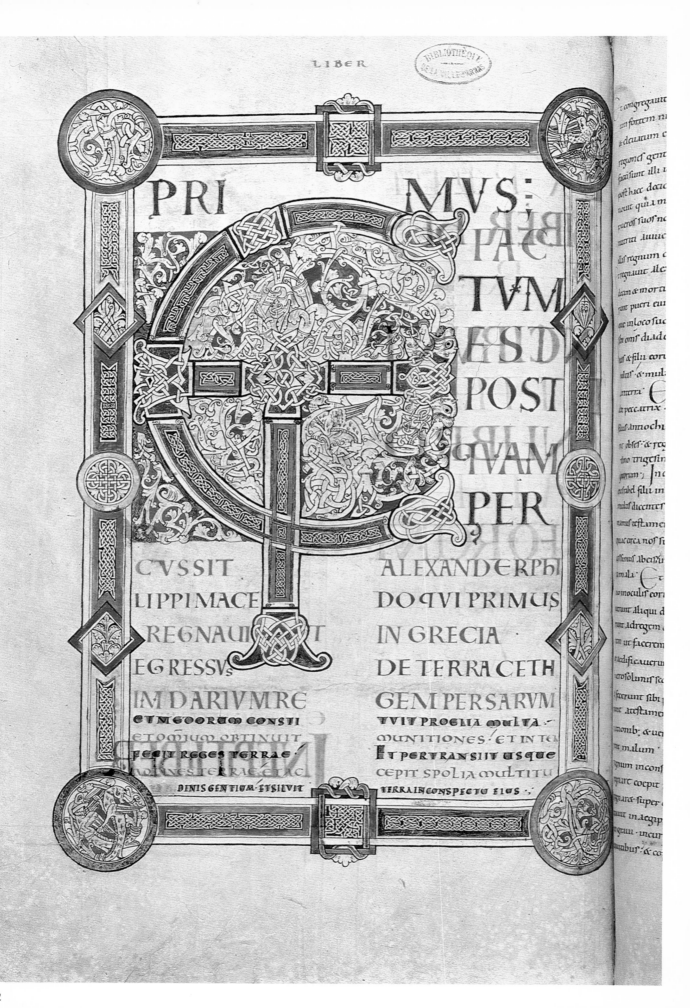

PRI MVS:

PER CVSSIT ALEXANDER Ph

LIPPI MACE DO QVI PRIMUS

REGNAVIT IN GRECIA

EGRESSVs DE TERRA CETH

IM DARIVM RE GEM PERSARVM

ET MEDORVM CONSTI TVIT PROELIA MVLTA

ET TOTIVM OBTINVIT MVNITIONES · ET IN TE

FECIT REGES TERRAE · ET PERTRANSIIT VSQUE

AD FINES TERRAE · ET AC CEPIT SPOLIA MVLTITV

DINIS GENTIVM · ET SILVIT TERRA IN CONSPECTV EIVS ·

PLATE 22

THE BIBLE OF SAINT VAAST, VOLUME III
fol. 52v *Et. Opening of the Book of Maccabees, I*

At the Monastery of Saint Vaast near Arras in Northern France, the early
eleventh-century manuscripts show the same combination of influences as at Saint
Bertin (Plate 21). Here the initials *Et* and the frame with the interlace filling are
clearly indebted to illuminated manuscripts of the Carolingian Franco-Saxon
school still preserved in the libraries of the monasteries of the area in which they
were originally made (Plate 9). The three-dimensional leaf scroll with its in-
tertwined birds and dragons, on the other hand, was derived from Anglo-Saxon
manuscripts of the tenth and eleventh centuries. The combination had already
been made in the *B* of the *Harley Psalter* from Winchester (Plate 15), but the idea
was taken up and developed further in the Northern French and Norman abbeys.

 This great *Bible* in three volumes, containing miniatures as well as initial pages
by a number of different artists, was preserved at Saint Vaast until the secularization
at the French Revolution, when it came to Arras.

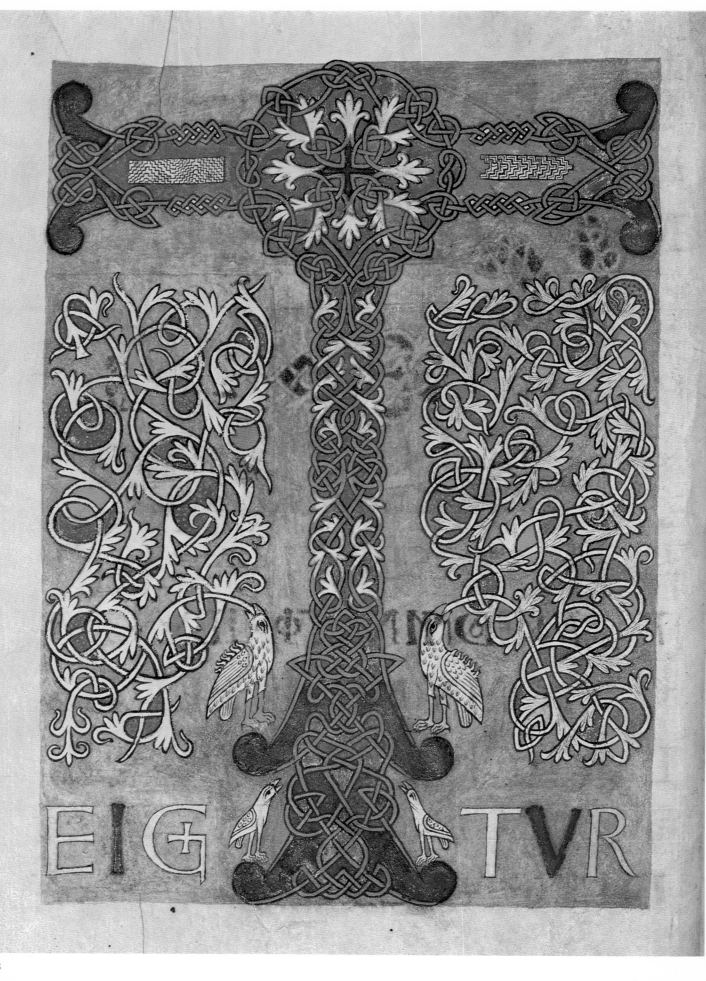

PLATE 23

THE FIGEAC SACRAMENTARY
fol. 19v *T. Canon of the Mass*

This initial is formed of interlace and scrollwork set on a purple ground. From the beaks of the birds flanking it, comes an interlacing scroll silhouetted in white on the purple, from which, in turn, flat, pointed leaf forms develop. This type of scroll is typical of Southern French manuscripts in the area of Aquitaine from the early eleventh to the early twelfth century. It has been compared to both Islamic and Byzantine foliage scroll, but, although some influence from such sources via Spain or Southern Italy is not impossible, it seems more likely that the scroll developed independently from Carolingian, particularly Tours and Franco-Saxon school manuscripts, which themselves began the process of stylization of Late Antique foliage ornament (Plates 7–9). Whatever its sources, it is completely different from the turning, three-dimensional leaf forms found in contemporary Northern French manuscripts and derived from Anglo-Saxon sources (Plates 21, 22).

The *Sacramentary* was made for Saint Sauveur, Figeac, Lot, in the diocese of Cahors and seems to have reached the Abbey of Moissac shortly after. In 1678, J. B. Colbert, finance minister of Louis XIV, bought five hundred manuscripts from the Abbey including the *Sacramentary,* and these were acquired with the rest of Colbert's manuscripts by Louis XV in 1732.

PLATE 24

FLORUS, COMMENTARY ON SAINT PAUL'S EPISTLES,
VOLUME I
fol. 1 P. *Epistle to the Romans*

In the oval at the top of the stem of the letter, Saint Paul is shown with a scroll
which extends into the bowl of the letter where it is held by the Deaconess Phebe
(Romans 16:1). Saint Paul is recommending her to the Romans who are shown
standing outside the gates of Rome. Both are labeled on a band appearing above
their heads, and above this is a blessing figure of Christ. To the right is a portrait of
the scribe who signs the manuscript at the end—Johannes Monoculus (one-eyed)
—in 1163–64, saying that he wrote it upon the order of Richerus, Sub-Prior of
Saint Peter's Abbey, Corbie near Amiens. Richerus is shown in the second roundel
of the stem of the *P* and the third figure is also labeled (Felix). He appears to be the
illuminator of the manuscript, and is shown working on a lapboard perched on his
knee with a little pan of paint on the board. He is represented as a layman, and in
the twelfth century we begin to have considerable evidence of the existence of
professional, paid illuminators who would, in the next century, come to predomi-
nate over monastic craftsmen.

The initial shows an early stage in the development of the so-called "white lion"
type of decoration in which lions, birds, or other animals are enmeshed in a
thinner, stringier type of scrollwork (Plate 20). The initial is set on a framed
pattern background which separates it from the script and this would develop into
the characteristic Gothic initial frame. There are also three smaller initials on the
page, decorated with arabesque scrolls, the forerunners of Gothic *fleuronnée* ini-
tials.

The manuscript with its second volume remained at Corbie until it was removed
to Saint-Germain-des-Prés for safety in 1638. From there it passed to the Bib-
liothèque Nationale at the French Revolution.

PHEBES ROMANI ROMA

PAVLVS SERVVS XPI IhESV
uocatus apls segregatus in euuglium di qd
ante promiserat p pphas suos in scpturis scis
de filio suo qui factus e. ei ex semine dauid
secdm carnem: qui pdestinatus e filius di in uir
tute. secdm spm scificationis et resurrectione
mortuorum ihu xpi domini nri. Ex libro
Paulus apls. Qui cum Idespu et littia
Saulus prus uocaretur. ñ obaliud cum
tum in uidetur hoc nomen elegit ii ut se
ostendet paruum tanqm minimu aplom.
Multum contra supbos et arrogantes.
et de suis opibz psumentes p comendan
da di gram fortt atqz acrit dimicat: quia
re uera in illo euidentior et clarior appa
ruit. qui cum talia oparetur. uehement eccl
am di psequens p quibz summo supplicio di
gnus fuit. miscdiam p dampnatione suscep
pit: et p pena consecutus est gram. Merito
pro eius defensione clamat atqz concertat.
Nec in re pfunda et nimis abdita minus
intelligentii et uba sua sana in psum sen
sum detorquentium curat inuidiam: du
tamen incunctant predicer donum di. quo
uno salui fiunt filii pmissionis. filii benefi
cii diuini. filii gre et miscdie. sui testamen
nous. Primum quod omnis eius salutatio
sic se habet. Gram nobis et pax a do patre nro
et domino ihu xpo. Deinde ad romanos.
pene ipsa questio sola usatur tam pugnaci
ter. tam multiplicit. ut fatiget quide legen
tis intentionem: z tam fatigatione utili ac
salubri. ut interioris hominis magis exerceat

membra quam frangat. Ex tractatu psalm. LXI. II
emento de synagoga fuisse arietes. quorum filii sum?
Unde dr in psalmo. Afferte dño filios arietum. Qui
inde arietes? Petrus. iohes. iacobz. andreas. bartolo
meus. et ceti apli. Hinc et ipse primo saulus. postea
paulus. id est pmo supbz. postea humilis. Saulus
enim dictus e. Nomen saul nostis: quia rex supbus
et infrenis fuit. Hon quasi iactantia aliqua nomen
z mutauit apls. sz et saulo factus e. paulus. ex supbo
modicus. Paulum enim modicum est. Vis nosse quid
sit saulus. Ipsum audi iam paulum. recor dantem
quid iam fuerit. p malitiam suam: et quid iam sit p
gram di. Audi quo iñ fuerit saulus. et quomodo sit
saulus. Qui fui prius inquit blasphemus et psecutor
et iniuriosus. Audisti saulum: audi et paulum.
Ego enim sum inquit minimus aplorum. Quid est
minimus. nisi ego sum paulus. Et sequit. Qui noñ
sum dignus uocari apls. Quare? Quia fui saulus. Ed
est fui saulus? Ipse dicat. Quia psecutus sum inquit
eccliam di. Sz gra di ait sum quod sum. Abstulit subi
omnem granditate suam. Minimus iam in se: gran
dis in xpo. Ex sermone de aplo paulo.
ste uas electionis. primo saul a saule. Recor dam inii eni
qui nostis litteras di. quis erat saul. Rex pessimus. p
secutor disertus sci dauid. et ipse si mem iniistis de tribu
beniamin. Inde iste saulus ducto secum tramite se
uiendi: sz inseuicia iñ pmansurus. Postea si saulus
a saule: paulus unde? Saulus a rege seuo. cum supbus
cum seuiens. cum cedes anhelans. Paulus autē unde?
Paulus. quia modicus. Paulus humilitatis nomen est.
Paulus postea quam adductus est ad magistrum q art
discere ame quia minus sum et humilis corde. Inde paul?
uiñ tamñ locoratus adustrie cha paruut modestde. paulo pe iñ se
re paulum expecta. ide p siac ccñt uide bor e medicium ne expecta.
Audi q paulum. Ego sum minimus aplorum. Pror
sus ego sum inquit minimus aplox. Et alio loco. Ego
sum nouissimus aplorum. Et minimis et nouissim?
tanquam fimbria de uestimento di. Quid tam exi
guum qm fimbria? Hac tamen tacta: mulier a flu
xu sanguinis sanata e. In modico isto magnus erat.
in minimo grandis habitabat: et tanto minus a se
magnum excludebat. quto magis minor erat. Quid
miramur magnum habitare in angusto. Magis
minimus habitat. Audi illum dicentē. Sup quē
requiescit sps meus? Sup humilem et quietum. et
tremente uba mea. Ideo altus habitat in humilib:
ut humilem exaltet. Excelsus e dñs et humilia res
picit. excelsa autē a longe cognoscit. Humilia te.

PLATE 25

JOSEPHUS, ANTIQUITATES JUDAICAE, VOLUME I
fol. 3 *In. Book 1*

The *In* monogram introducing the words *In principio Deus creavit celum et terram,* "In the beginning God created the Heaven and the Earth," is linked by a series of overlappings. The N seems to be placed on top of the I, but the gold outline of the uprights of the N turns into leaf scrolls in gold and silver which also fuse with the outline of the I. Since the opening words of Josephus's text are the same as those of the Book of Genesis it is natural that a similar initial design and similar scenes are to be found in a number of Romanesque Bibles. The seven roundels with the scenes of the six days of Creation and God resting on the seventh day, which are often placed one above another in the stem of the I, are placed here on either side and in the center of the N. Two other roundels show a King and a Queen holding flowering sceptres, perhaps representing Solomon and Sheba, or the Old and New Testaments. The four figures pouring water from vases represent the four rivers of Paradise. The monogram is set on a diapered ground, and the intervals of the monogram are in green and red. There is also an outer frame in silver, which has blackened, with a rich leaf scroll and half roundels with various scenes including, at the sides, below, the Crucifixion; opposite, *Ecclesia,* the Church; and, above, two prophets. At the top, Aaron and the Manna, and the Sacrifice of Abraham are shown, and below, a corpse, perhaps the dead Adam, and Christ rescuing the souls from the Jaws of Hell. Such typological scenes (that is, events paralleled in the Old and New Testaments) are typical of Romanesque manuscripts produced in the area of the Meuse.

The manuscript bears the contemporary ownership inscription of the Abbey of Saint Trond in Belgium where it was made c. 1170–80. A number of papal bulls in favor of the Abbey were also copied into it. By the nineteenth century it appears to have reached a convent in Portugal and was later presented to an English general during the Napoleonic wars. It was bought from the London bookseller Boone by Ambroise Firmin-Didot and purchased at his sale in 1881 by the Duc d'Aumale, thus forming part of his bequest to the Institut de France in the Musée Condé.

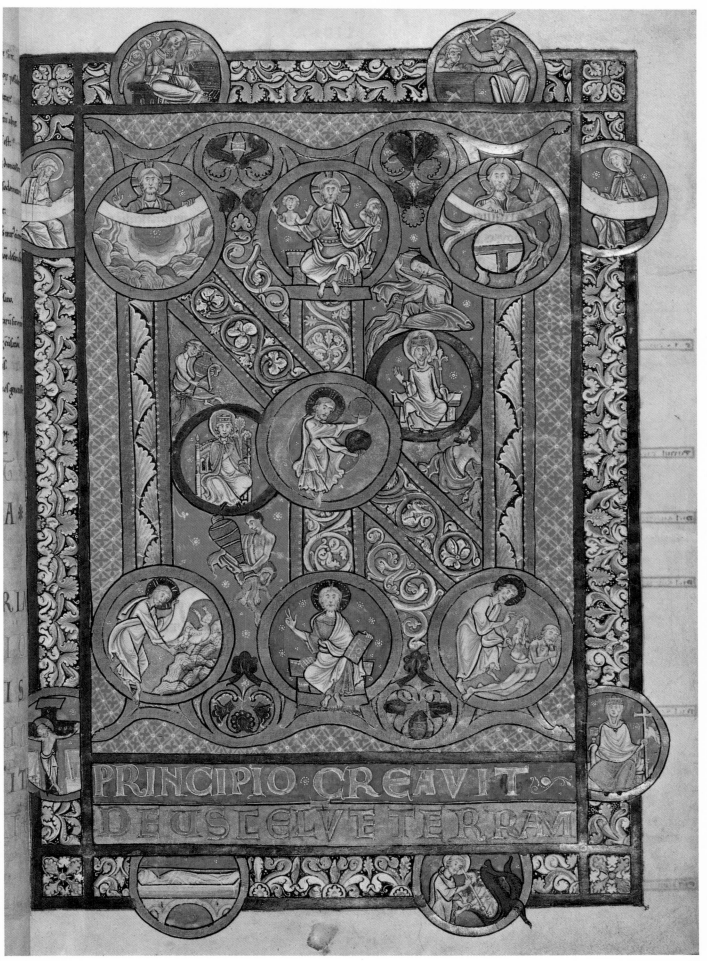

PRINCIPIO CREAVIT
DEUS CELVE TERRAM

erat uerbum. & uerbum erat apud dm̄. & deus
erat uerbū. Hoc erat in principio apud dm̄. Oĩa
p̄ ipsū facta sunt: & sine ipso factum est nichil.
Quod factū ē. in ipso uita erat. Et uita erat lux
homīnū. & lux in tenebris lucet. & tenebrȩ eam
non ↄprehenderūt. Fuit homo missus a dō: cui no
men erat ioh̄s. Hic uenit in testimonium ut testimo
nium p̄hiberet de lumine: ut oīs crederent p̄ illū.
Non erat ille lux: sed ut testimonū p̄hiberet de

lumine: Erat lux uera: quȩ illuminat omnē ho
minē uenientē in hunc mundū. In mundo erat et
mund⁹ p̄ ipsū fact⁹ est: & munchus eū non cognouit.
In propria uenit: & sui eū non receperūt. Quotquot autē
receperūt eum: dedit eis potestatē filios dī fieri hiis
q̄ credunt in nomine ei⁹. Qui nō ex sanguinib⁹: neq̄
ex uoluntate carnis: neq̄ ex uoluntate uiri: sed
ex dō nati sūt. Et uerbū caro factū ē. & habitauit in
nobis. Et uidim⁹ glam̄ ei⁹. glam̄ quasi unigeniti. a

Caput Primū
Christus ab eterno Deus et ex tempore homo. Ioannis Baptistȩ testimoniū
p̄hibetur. et quosdam discipulos uocat.

26

PLATE 26

THE ARNSTEIN BIBLE, VOLUME II
fol. 185v *In principio. Opening of Saint John's Gospel*

This large *Bible* in two volumes is written in two columns. The folio reproduced here for the opening of Saint John's Gospel, shows the upper three-quarters of the page set apart to enclose the words *In principio* within a frame of continuous leaf scroll in white drawn in red and set on blue, yellow and green. The letters *In* act as a trellis for a richly colored scroll which is set off by the gold background. The N is emphasized as the central stabilizing factor in this whirl of color and pattern by its black, central filling; the enlarged central leaf with its blue stalk and flanking silver panels has the same effect. The letters to the right, *principio,* are mainly in gold and silver with tones of rose and pink to contrast with their irregular backgrounds of green and blue.

The right upright of the N has been shortened to allow a corner into which Saint John, his symbol, the Eagle, and a blessing, half-length figure of Christ are fitted. Typical of Romanesque art is the way the saint is "anchored" to his setting so that he does not float free in space; the top of the N acts as if it were a column supporting the footstool and throne. In the bottom left corner a bearded half-length man grasps the scroll of the *I* like an atlas figure (such figures are common in Roman-esque sculpture). It is not easy to say if the figure has a meaning or not, but formally the function of support seems to complement the function of the column of the N and so leads the eye diagonally up to the Evangelist. The blue panel in the top right corner also echoes the atlas figure's blue cloak.

The *Bible* has the ownership inscription of the Premonstratensian Abbey of Arnstein founded in 1139 near Coblenz in the Rhineland, and was written there in 1172 by Brother Lunardus, as a fragmentary Annals, formerly bound with the *Bible*, shows. Stylistically it shows the influence of contemporary Mosan illumination (Plate 25).

PLATE 27

BEATUS, COMMENTARY ON THE APOCALYPSE
fol. 6 A.

In the late eighth century a Spanish monk, Beatus of Liébana, wrote a commentary on the Apocalypse which was illustrated with a long cycle of scenes. Although the original did not survive, there are a considerable number of copies from the tenth through twelfth centuries, of which this is one of the most splendid, containing more than one hundred miniatures. It is dated 1047 and signed by the scribe, Facundus, who wrote it for Ferdinand the Great of Castile, León (1037–65) and his queen, Sancha. Ferdinand later gave it to the Cathedral of San Isidoro, León, where he and his wife were buried.

The text begins and ends with full-page representations of the first and last letters of the Greek alphabet, *alpha* and *omega,* alluding to the words of Apocalypse 1:8 and 21:6: "I am alpha and omega, the beginning and the end." The great *alpha* dominates this page overlapping the frame at the top. It is mainly composed of interlace, but the ascending shafts of the letter are countered by two pairs of motifs circling downwards—below, bird heads from whose beaks come half-length angels and above, dogs or lions swallowing peacocks. Below, in the center, the figure of Christ holds up the *omega* in His left hand, the central vertical axis emphasized by the interlace and leaf rosette above His head. The two angels above must be seen as worshiping Him, but typically the early Romanesque artist assimilated them into his total, abstract design, removing them from any naturalistic spatial relationship with the Christ. Many of the decorative motifs and the stylized figures in the *Beatus* manuscripts appear to be influenced by Islamic art in the Peninsula. But as Guilmain has shown, the initial styles depended above all on Carolingian manuscripts of the Franco-Saxon school.

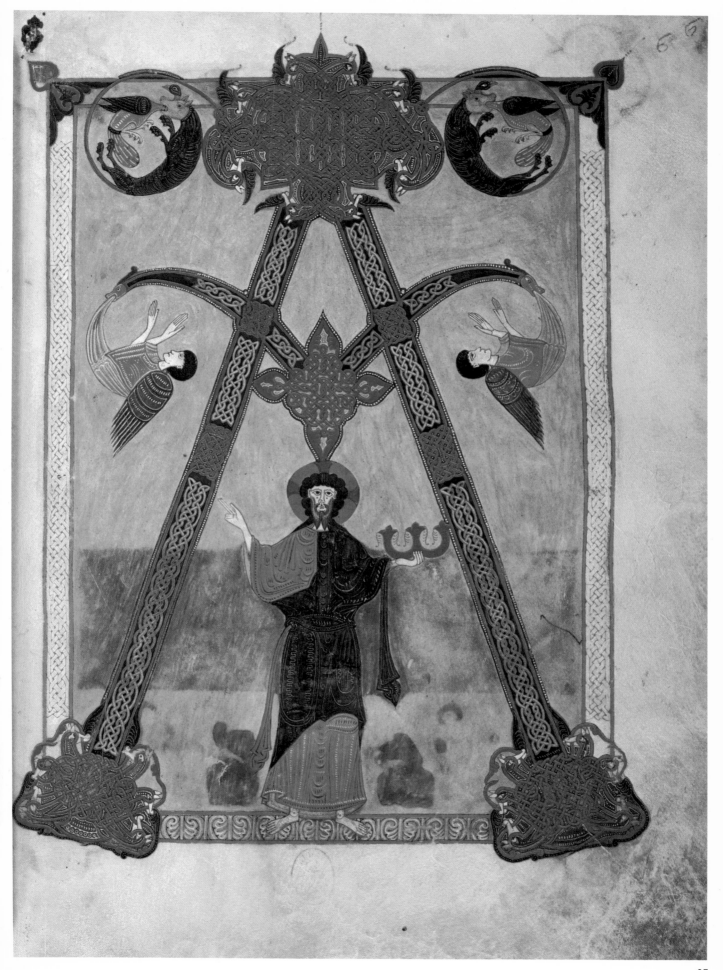

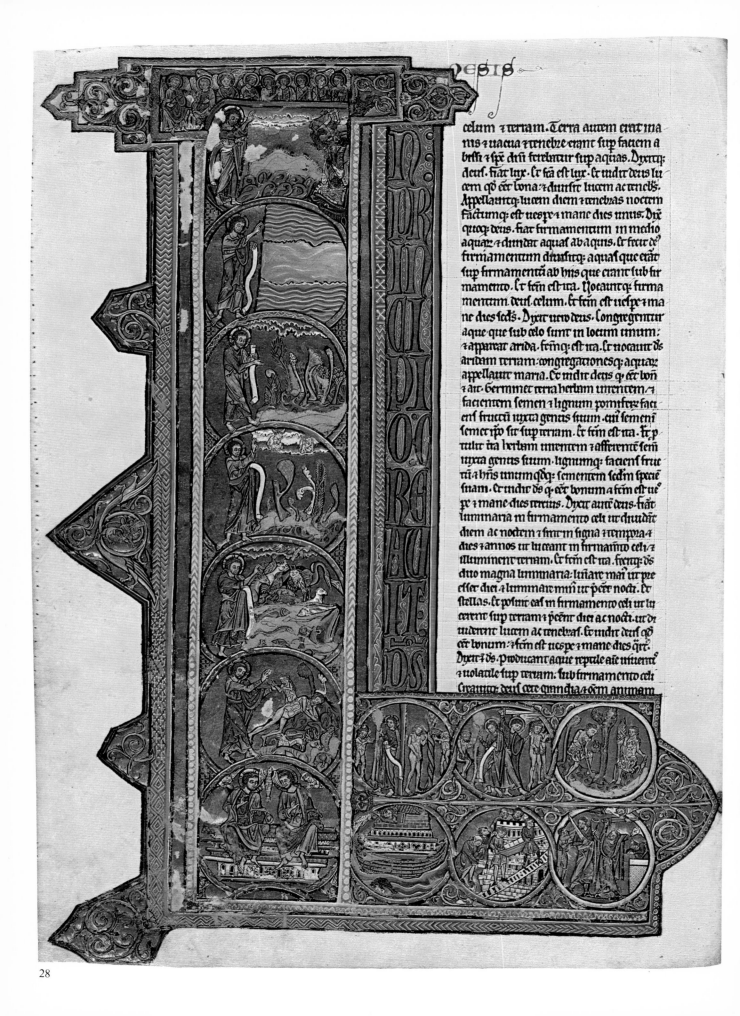

celum ⁊ terram. Terra autem erat ina
nis ⁊ uacua ⁊ tenebre erant sup faciem a
byssi ⁊ spc dni ferebatur sup aquas. Dixitq;
deus. fiat lux. et fca est lux. et uidit deus lu
cem qd eet bona ⁊ diuisit lucem ac tenebs.
Appellauitq; lucem diem ⁊ tenebras noctem
factumq; est uespe ⁊ mane dies unus. Dix
itq; quoq; deus. fiat firmamentum in medio
aquarz ⁊ diuidat aquas ab aquis. et fecit de'
firmamentum diuisitq; aquas que erant
sup firmamentu ab hiis que erant sub fir
mamento. et fcm est ita. Uocauitq; firma
mentum deus celum. et fcm est uespe ⁊ ma
ne dies scds. Dixit uero deus. Congregentur
aque que sub celo sunt in locum unum:
⁊ appareat arida. factumq; est ita. et uocauit ds
aridam terram: congregationesq; aquarz
appellauit maria. Et uidit deus qd eet bon
⁊ ait. germinet terra herbam uirentem ⁊
facientem semen ⁊ lignum pomiferz faci
ens fructu iuxta genus suum. cui semen
semet ipo sit sup terram. et fcm est ita. et p
tulit tra herbam uirentem ⁊ afferentem sem
iuxta genus suum. lignumq; faciens fruc
tu ⁊ hns unumqdq; sementem secdm specie
suam. et uidit ds qd eet bonum a fcm est ue
spe ⁊ mane dies tercius. Dixit aut deus. fiat
luminaria in firmamento celi ut diuidat
diem ac noctem ⁊ sint in signa ⁊ tempora ⁊
dies ⁊ annos ut luceant in firmamento celi ⁊
illuminent terram. et fcm est ita. fecitq; ds
duo magna luminaria: luxare mai ut pre
esset diei ⁊ luminare min ut peet nocti. Et
stellas. et posuit eas in firmamento celi ut lu
cerent sup terram ⁊ peent diei ac nocti. ut di
uiderent lucem ac tenebras. et uidit deus qd
eet bonum. ⁊ fcm est uespe ⁊ mane dies quar.
Dixit ⁊ ds. producant aque reptile ale uiuent
⁊ uolatile sup terram: sub firmamento celi
creauitq; deus cete grandia ⁊ oem animam

PLATE 28

THE BIBLE OF ROBERT DE BELLO
fol. 5v *I. Opening of the Book of Genesis*

Although this page looks as if it contains a series of roundels with scenes, the main
component is an initial *I* introducing the first words of Genesis *In principio,* "In the
beginning." A closer look reveals that the letter form is outlined by a pale pink
border. The roundels contain, from the top, scenes of the Fall of the Rebel Angels
with the Holy Angels above; God dividing the waters from the Earth; the creation
of the Planets, of the Sun and the Moon, of the animals and fishes, and of Eve from
the side of Adam. Lastly, at the bottom the Trinity—two Persons and the Holy
Spirit—is shown. Further scenes from Genesis, in intertwining roundels, show
God's commandment to Adam and Eve, the Temptation, the Fall and Expulsion
from Paradise, Adam digging and Eve spinning, Noah's Ark, the building of the
Tower of Babel, and Abraham's sacrifice of Isaac. The pink frame and the outer,
blue frame continue below to link in these scenes. The overlapping three-quarter
circles of the initial, the repeated standing figure of the Creator, the outer bands of
gold and blue variously patterned, and the gold letters of the opening words all
serve to emphasize the vertical accent of the initial. The letter was executed, as was
usual, after the script since it overlaps the text below. Above, it was also necessary
to erase part of the running title of the book, *Genesis.*

Contemporary and later inscriptions inform us that the *Bible* belonged to
Robertus de Bello, Abbot of Saint Augustine's Abbey, Canterbury, from c. 1224 to
1253. It is not known where it was produced, but it was likely made nearer the end
than the beginning of his term, since the style can be compared to that of the *Salvin
Hours* (Plate 29).

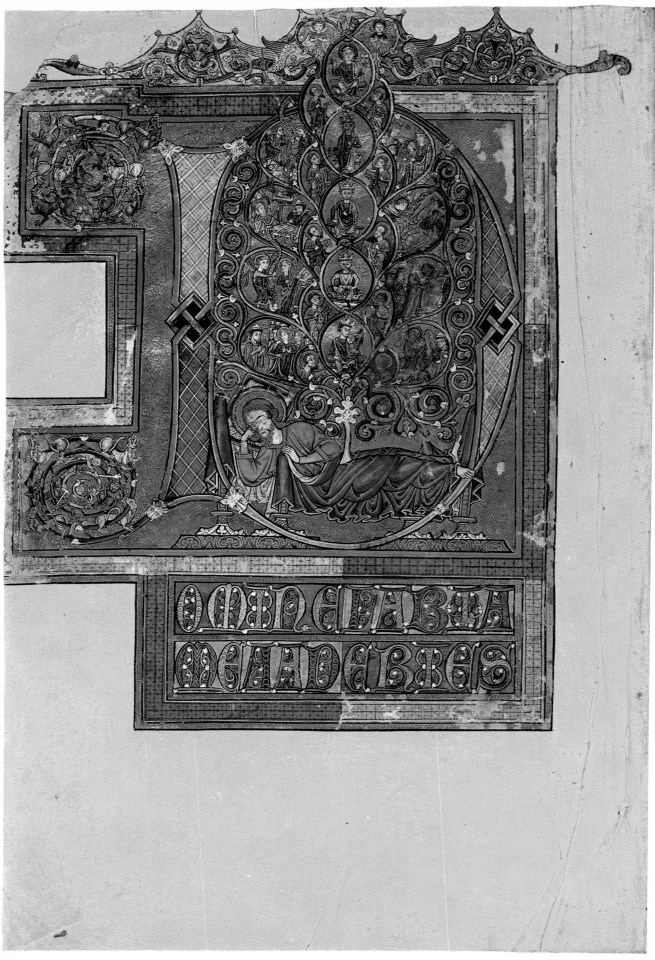

29

PLATE 29

THE SALVIN HOURS
fol. 1v *D. Opening of the Hours of the Virgin*

The initial *D* introduces the words *Domine, labia mea aperies,* "O Lord open thou our lips," which appear below. It is historiated with a Tree of Jesse, a diagrammatic representation of Jesus Christ's descent from King David, son of Jesse (Matt. 1:1-17). Jesse lies asleep with the family tree growing out of his loins and in it are shown: first, David with his harp; then, two other Kings of whom the first is probably Solomon, David's son; then the Virgin Mary; and, lastly, Christ with the Holy Spirit and two Cherubim hovering above His head. The flanking figures are probably Old Testament prophets, although unidentified. The representation of the Tree which first appears in the eleventh century is based on the prophecy of Isaiah *Ecce virgo concipiet,* "Behold a virgin shall conceive," and also *Egredietur virga de radice Jesse et flos de radice ejus,* "The flower from the stem of Jesse" (Isaiah 7:14 and 11:1). In addition, various scenes from the early life of Christ, from the Annunciation to the Flight into Egypt, are shown.

The anonymous Gothic artist used the frame of the *D* like a trellis into which he interlaced the scene. Jesse's bed seems to lie behind the letter but his right foot overlaps it, and the Tree at the top continues above the letter and into the frame beyond. In the tendrils of the letter, a lively lion fight is taking place, a survival from earlier Romanesque initials (Figure XI). Unfortunately the page has been cropped and in parts damaged, so that the scenes on the right are blackened, and some of the gold leaf has flaked.

The manuscript has other historiated initials for the other Hours, and numerous initials painted with leaf scroll in gold and colors. Liturgical evidence points to its having been produced in the Diocese of Lincoln after 1262, and there are stylistic links with a known illuminator, William de Brailes, who worked in Oxford, at that time part of the Lincoln diocese.

The manuscript takes its name from its former owners since the seventeenth century, the Salvin family of Croxdale, County Durham. It was bought from them by Henry Yates Thompson in 1904 and acquired from him in 1920 by Sir Alfred Chester Beatty, who gave it to the British Museum in 1955.

PLATE 30

The Windmill Psalter
fol. 2 *E. Psalm I*

The initial *B* of Psalm 1 is on the verso opposite this recto page upon which the rest of the word (*B*)*eatus* appears. The initial *E* is enlarged and placed against a highly ornate pattern of vine leaves tinted green and placed on a stippled ground of blue or red. Below, an angel flies down towards us in a strikingly foreshortened pose, and holds a plaque upon which the verse continues—(*e*)*atus vir qui non abiit*—in gold.

On the crossbar of the *E* the story of the Judgment of Solomon (I Kings 3:16–28) is represented with the enthroned King, the two mothers, and the soldier about to divide the surviving child. The artist has also added a number of finely observed details, the windmill, above, from which the *Psalter* takes its name, and a pheasant below. Smaller initials introduce verses 2 and 3, and a space at the end of a line is filled by a grotesque with human head and dragon body, also painted by the main artist.

This initial is a good example of the Gothic use of a transparent layered space. The initial does not act as a window frame for the scene. Instead, the figures are placed so that they overlap it. A subtle detail is the way in which the soldier's right foot only is overlapped by the extension of the crossbar of the *E*. This emphasizes his twisting pose so that he seems to turn back into space away from us. The letter shape is a second layer, and the penwork decoration a third.

The figures were painted by an English artist c. 1270–80. Characteristics of his style are the curly locks of hair, the coloring (especially the use of olive green highlighted in gold) and the spectacular penwork decoration. Such penwork was often executed by specialist craftsmen, but since it is also found in other manuscripts by the artist and since here not only is there no sign of a break but the scrollwork is an essential part of the whole design (for instance in the way it echoes the figures' movements), there can be no doubt that the penwork is by the artist himself.

The *Psalter* was the last manuscript purchased for his library by William Morris before his death in 1896. It was acquired by J. Pierpont Morgan in 1908.

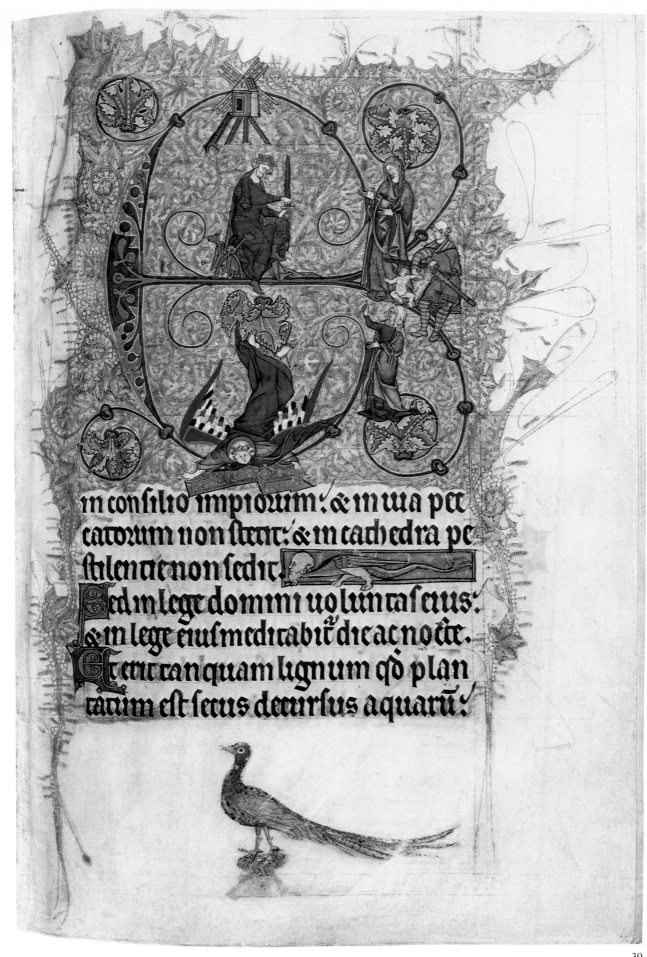

in consilio impiorum: & in uia pec
catorum non stetit: & in cathedra pe
stilentie non sedit.

Sed in lege domini uoluntas eius:
& in lege eius meditabit dic ac nocte.

Et erit tanquam lignum qd plan
tatum est secus decursus aquaru:

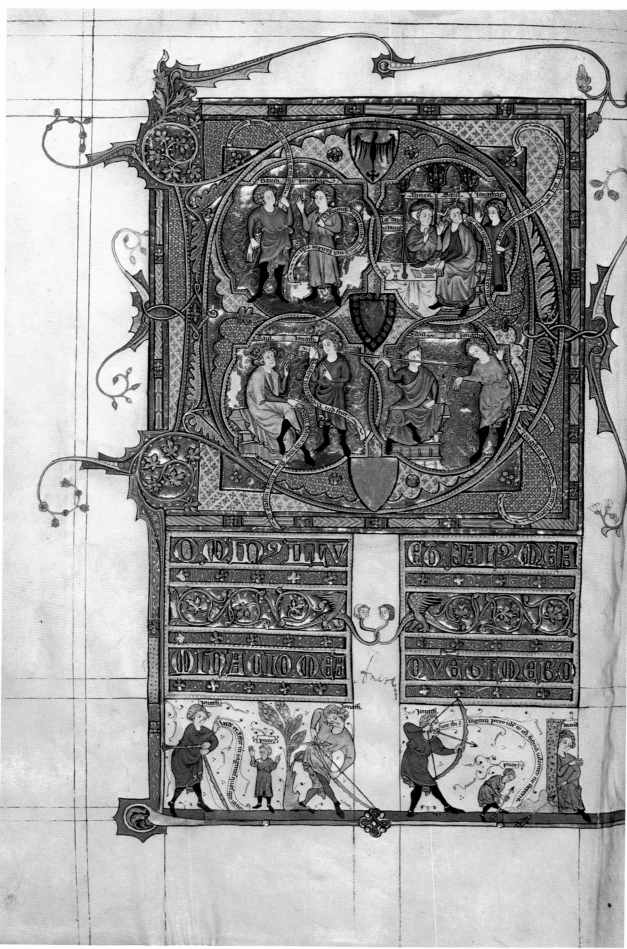

31

PLATE 31

THE TICKHILL PSALTER
fol. 26v D. *Psalm 26*

A fifteenth-century inscription in this *Psalter* records that it was written and gilded by John Tickhill, Prior of Worksop, an Augustinian Priory in Nottinghamshire. He was appointed in 1303 and removed for maladministration in 1314. The manuscript was to have been very richly illuminated throughout, and the illumination seems to have been entrusted to a traveling workshop employing a number of different artists. The program of historiated initials and marginal scenes was never completed, however, and there is an interesting series of unfinished pages showing the various stages of the artists' work.

The manuscript contains a large number of scenes from the lives of David and his son Solomon. On this page in the initial, above, David is shown with his friend Jonathan, Saul's son, on the left; and on the right is David's empty place at the King's table, which David had left in fear for his life; below, the jealous Saul speaks to his son and threatens him with a spear. In the margin Jonathan fires the arrows to warn David he is in danger and sends the boy to collect them (I Samuel 20:35–9). The story is explained by labels identifying the actors and by speech scrolls which are like the speech balloons in modern cartoons. The artists also used the scrolls with expressive purpose in their designs, and the page is made up of a lively interplay of the curving forms of the scrolls, of the initial, of the border motifs, and of the filling scrolls below. The manuscript is written in two columns throughout so that the gold letters of the text below, *Dominus illuminatio mea,* are on two panels. These are "tied together" by the leaf scroll ending in the center with human-headed dragons.

The *Psalter* was acquired after the Lothian sale in 1932. It had probably belonged to William Kerr, Third Marquis of Lothian (1722–67), and on this page is the signature of a later member of the family, William Kerr, Earl of Ancram (1775–1815).

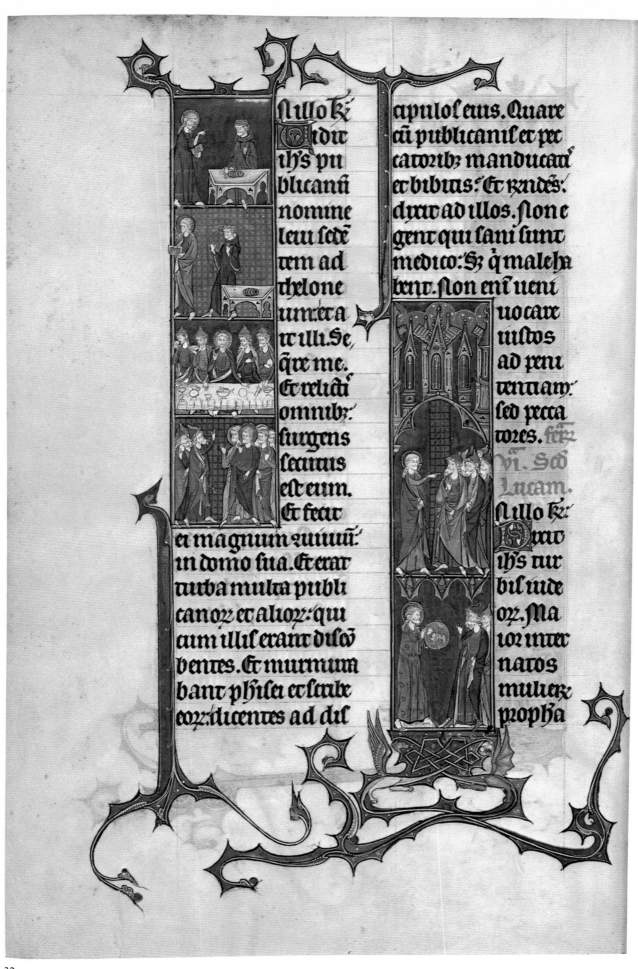

Sillo k̃ | apuloſ eius. Quare
Tendit | cū publicaniſ et pec
ih's pu | catonbʒ manducat'
blicanū | et bibitis? Et r̄ndēs:
nomine | dixit ad illos. ſlon e
leui sedē | gent qui sani sunt
tem ad | medico:S; q̃ male ha
thelone | bent. ſlon enī veni
um:et a | uocare
it illi. Se | iuſdos
qre me. | ad peni
Et relicti | tentiam.
omnibʒ | sed pecca
ſurgens | tores. fer
secutuſ | vi. Sctō
est eum. | Lucam.
Et fecit | Sillo kr
ei magnū̃ ẽuiuiū̃: | Dixit
in domo sua. Et erat | ih's tur
turba multa publi | biſ iude
canoʒ et alioʒ:qui | oʒ. Ma
cum illiſ erant disco | ior inter
bentes. Et murmura | natos
bant phiſei et scribe | muliez
eoʒ:dicentes ad diſ | propha

PLATE 32

EVANGELIARY OF THE SAINTE CHAPELLE, PARIS
fol. 130v *I.*

On this page we see a Gothic artist seeking a new solution to the problem of combining the script, the initial, and the illustration. He placed a series of small scenes one above another, and these suggest the vertical stem of the initial *I* for the introductory Gospel passages, *In illo tempore,* "At that time." Robert Branner has called these initials "ladder initials." Strictly speaking, however, there is really no letter *I,* no independent letter shape at all, for the vertical and horizontal gold lines are only the frames of each little scene. The artist thus abandoned the idea of the historiated initial and substituted for it a series of independent pictures. However, although the figures are modeled and move in space, and even sometimes seem to move out of the frame (for example Christ leaving Levi on the left), there is still no receding continuous space behind them. The flat background is intentionally emphasized by panels of pattern, and the border motifs also anchor the scenes to the two-dimensional surface of the page upon which the text is written.

The scenes on the left are Christ calling the tax collector Levi and at supper in his house (Luke 5:27), and, on the right, Christ preaching and Saint John the Baptist preaching (Luke 7:28). The manuscript was made c. 1255–60 for use in the Sainte Chapelle, Paris, which had been built in 1245–48 by Saint Louis to house the precious relics of the Crown of Thorns bought from Constantinople.

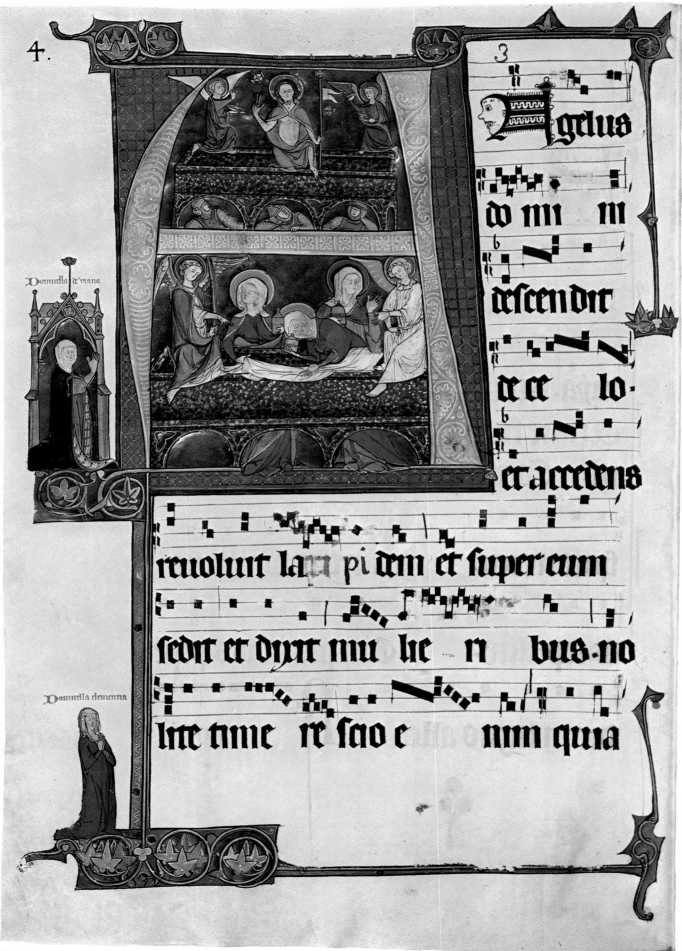

PLATE 33

THE BEAUPRÉ ANTIPHONAL
fol. 3v A. *Antiphon for Easter Sunday*

This initial A contains two scenes for Easter. Above the crossbar of the letter, Christ rises from the tomb flanked by censing angels. The three sleeping soldiers seem to lean on the letter. Below, the three Marys find the empty grave, which is shown as a Gothic marble sarcophagus with two angels seated on it, and examine the grave clothes. The A is in pink, set on a contrasting blue ground, and frames the figures—except for one angel's wing above and the feet of the Marys below. The scribe or the rubricator decorated the *N,* next letter of the word *angelus,* with a grotesque face.

A contemporary inscription beautifully written in alternate lines of red and blue tells us that the manuscript was written in 1290 for the Church of Saint Mary, Beaupré. This is identifiable as the Cistercian Nunnery of Beaupré near Grammont in Belgium, since two donors on this page are identified by inscriptions, Domicella de Viane and Domicella Clementia, and the Viane family is recorded as having been a benefactor of this particular Abbey. In addition to the historiated initials, there are also a number of marginal scenes in the manuscripts; others have, unfortunately, been erased at some time. One includes a portrait of the scribe, Johannes, who is shown as a monk.

Three volumes survive out of a set of six choir books containing the words and music of the sung parts of the Mass. The other three volumes were burnt in a fire at Sotheby's in 1863. A seventh volume contains additions made in the fifteenth to seventeenth centuries. The volumes are of great size so they could easily be read by the nuns in the choir. The four volumes now in Baltimore were given by the Hearst Foundation in 1957, having belonged earlier to John Ruskin (d. 1900), Henry Yates Thompson, Sir Alfred Chester Beatty, and William Randolph Hearst. Ruskin cut out a number of leaves which are now scattered.

PLATE 34

LIBER SOLILOQUIORUM ANIMAE PENITENTIS
fol. 121v *I.*

This anonymous treatise on penitence is divided into four parts, and this initial
introduces the third part. The text refers to twelve stones taken from the river
Jordan, symbolizing twelve penances for the author who must climb an arduous
path carrying them to build an altar and so purge his sins. The artist has used the
stem of the letter to suggest the ascent, as the little figures, each carrying a stone to
add to the altar at the top, climb the path beside the river Jordan.

 The illumination is similar to that in manuscripts made at Avignon in the late
fourteenth century with a combination of French and Italian style. The manuscript
contains the arms and donor portrait of Galeotto Tarlati de Pietra Mala who was
made a Cardinal by Urban VI in 1378. It later belonged to the antipope Benedict
XIII (1394–1424) many of whose manuscripts passed into the hands of Pierre,
Cardinal de Foix, who gave them to the Collège de Foix at Toulouse founded by
him in 1457. It was bought from there by Colbert in 1680 and, with the rest of
Colbert's manuscripts, was bought by Louis XV in 1732.

PLATE 35

THE GOSPEL BOOK OF JOHN OF OPPAVA
fol. 2 *L. Opening of Saint Matthew's Gospel*

A colophon in the *Gospel Book* states that it was written in gold and illuminated in 1368 by Johannes de Oppavia, Canon of Brno. Oppava (Troppau) is in Czechoslovakia. The coats of arms in the manuscript show that it was made for Duke Albrecht III of Austria (1365–95), and it has been suggested that he intended it as a Coronation Gospel Book, which would explain both its exceptional lavishness, and also the striking archaic features in its decoration. The frames of the text and initial pages are updated versions of similar pages in Carolingian manuscripts of the Franco-Saxon school. One manuscript of this school was then and still is in Prague (Capitular Library Cim. 2). The manuscript is, therefore, a most interesting piece of fourteenth-century historicism.

The shape of the *L* on this page is filled with music-making angels, and the central panel contains a scroll of dragons with human heads, as well as foliage tails. This seems to be a reworking of the theme of the Tree of Jesse, referring to Christ's descent from David, son of Jesse, which is described at the beginning of Saint Matthew's Gospel. There are overtones of Romanesque inhabited scrolls, or even the lacertine interlace of Insular art (Plate 1, Figure XI). The ends of the *L* turn into stalks and leaves which twine around the frame.

The artist was certainly working in Prague, and his style connects him with the illuminators active there in the 1360s under the patronage of Johann von Neumarkt, Chancellor of the Emperor Charles IV.

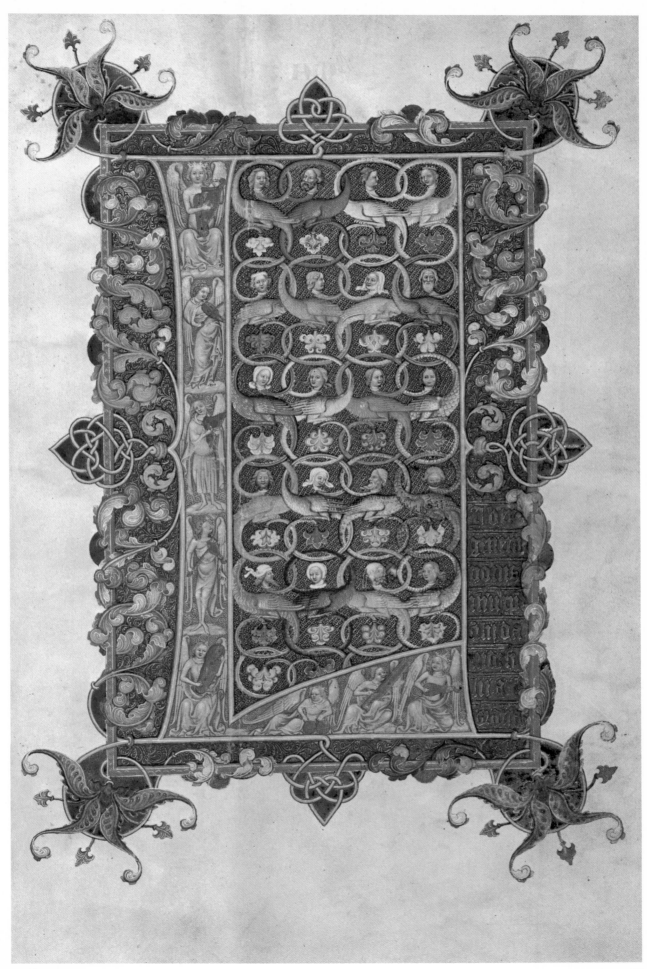

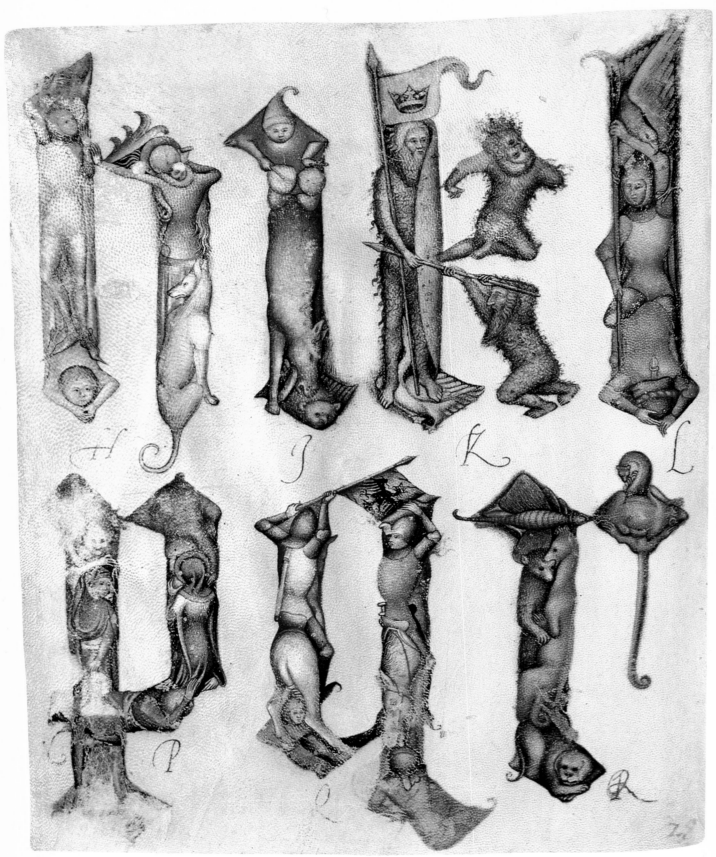

PLATE 36

THE SKETCHBOOK OF GIOVANNINO DEI GRASSI
fol. 29v *Figure Alphabet*

This sketchbook is a collection of parchment leaves bound together and contains mainly paintings of animals and birds, all of which have the appearance of studies from life. They are thus of great importance for the history of emergent naturalism in the later Middle Ages. However, there are also a few human figures and figure groups; a number of patterns, perhaps for textiles or embroidery; and some heraldic designs including the knot (nodo), emblem of Gian Galeazzo Visconti, Lord of Milan, who died in 1402. On one page is the inscription: *Johanninus de Grassis designavit.* The paintings in the book differ both in style and in quality, but the best of them are generally accepted on the strength of this apparently contemporary inscription as being by Giovannino dei Grassi, who is documented as having been an architect, sculptor, painter, and miniaturist. He was first mentioned in 1389, being referred to as *inzignerius* of Milan Cathedral in 1391, and he died in 1398.

On five pages there is a complete minuscule alphabet composed of figures and animals. On this page are the letters *h* to *r* and a later, sixteenth-century hand has identified them below in capitals. Such figure initials which first occurred in the eighth century and are a feature of Romanesque manuscripts, reappeared in French fourteenth-century manuscripts and seem to have been particularly developed in Bohemian illuminated manuscripts of the second half of the fourteenth century (Plate 35). Indeed, the *Bergamo Alphabet* seems likely to have been a copy of a Bohemian series of figure initials made c. 1370. Many of the letters, including the *k* and the striking *q* with the two horsemen, were later copied in the engraved alphabet of a German artist, the Master E.S., in the 1460s. The letters *a* to *g* in the *Bergamo Alphabet* seem to be by a different hand from the rest, and authorities differ as to whether any of the letters were by Giovannino himself or whether they were only copies made in his workshop or by slightly later followers.

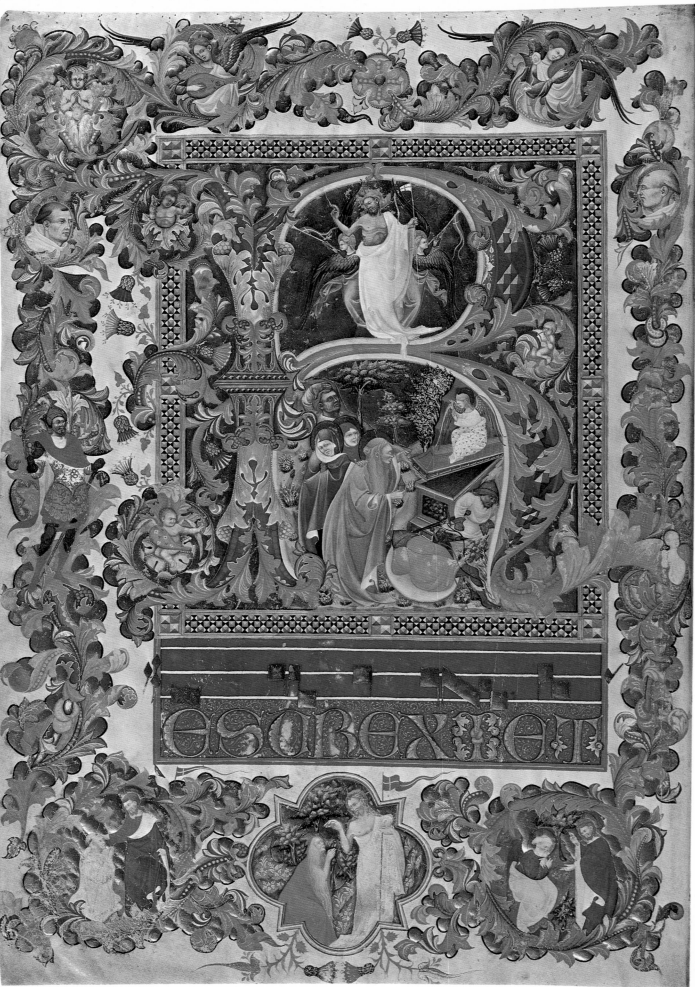

PLATE 37

GRADUAL
fol. 1v R. *Gradual for Easter Day*

This letter *R* contains the scene of the Resurrection with, below, the three Marys visiting the grave and, above, Christ flanked by two trumpet-blowing angels. The letter is decorated with acanthus leaves, and the scroll also contains nude *putti* and blue thistles. A band painted like a mosaic inlay with corner- and side-squares frames the *R*, although the letter's scrolling decoration overlaps it. There is also a leaf scroll border around the whole page, with three medallions below showing Christ appearing after the Resurrection to Saint Mary Magdalene and to Saint Peter, and on the left, Christ with a kneeling Camaldolese monk. The letters below, *(R)esurrexi et,* are also decorated with leaf scroll.

The *Gradual,* which would have been one of a set of great Choir Books (Plate 33), appears to have been made for use at the Camaldolese Monastery of San Mattia di Murano, Venice, in the first half of the fifteenth century. There are stylistic links with early fifteenth-century Florentine illumination of the Angeli school, both in the figure style and in such decorative details as the blue thistles. The *Gradual* has in the past been mistakenly attributed to a Lombard illuminator, Belbello da Pavia. Although the background of the scene is in gold with no representation of extending space, nevertheless, there is the beginning of an illusion of a scene seen through a window, as in later examples. It is interesting to compare earlier and later representations of the scenes (Plates 33, 39).

The manuscript belonged to William Beckford (d. 1844) and was inherited by his daughter and his son-in-law, the 10th Duke of Hamilton (d. 1852), who was also a noted collector of manuscripts. The Hamilton manuscripts were bought by the Prussian Government in 1882, but some of them, including the *Gradual,* were then resold in 1889. The *Gradual* was finally repurchased in 1903.

PLATE 38

VIRGIL, WORKS
fol. 17 Q. *Opening of the Georgics*

The title and the opening words of *Georgics, Book I*—*Quid faciat laetas segetes, quo sidere terram*—are written in gold and different colors. The initial *Q* is shown as if it were a carved, faceted, three-dimensional object carried by two satyrs with a third using it as a seat. The initial is set on a framed pink ground; a further conceit is that the end of the tail of the letter is shown lying below as if it had been too long to fit in and had to be broken off!

The miniature above shows ploughing and other country pursuits discussed in the poem. The whole page is framed with classicizing Renaissance ornament set on a purple ground. This is typical of many manuscripts illuminated for clients with antiquarian interests in Padua and Rome from the 1470s onward, especially those written by a famous scribe, Bartolomeo Sanvito of Padua. Although not signed, the manuscript is attributable to Sanvito who was notable for his use of epigraphic capitals, that is, capitals based on classical Roman inscriptions, and his developed Italic script. He may also have been an illuminator, and decorated this and other manuscripts himself.

The arms painted below are of Agneli of Mantua, and the passage in Aeneid 10:200 relating to Mantua is specially noted in gold. Since the same arms appear on other pages with a lamb and a bishop's hat, the manuscript must have been written for Lodovico Agneli, Bishop of Cosenza from 1497 to 1499. The manuscript was bought by King George III from Joseph Smith, British Consul at Venice.

P·VIRGILII MARO
NIS GEORGICON
LIBER·I·
AD MECAENATEM
VID FAC
AT LAE
TAS SE
GETES
QVO SIDERE TERRÃ

Vertere mecænas: ulmisq. adiungere uites
Conueniat: quæ cura boum: qvis cultus habendo

38

PLATE 39

GRADUAL
fol. 2 R. *Gradual for Easter Sunday*

In 1468 Girolamo da Cremona began to work on the illumination of a series of
Choir Books for Siena Cathedral, collaborating with a number of other artists, of
whom the best known is Liberale da Verona. A complete series of records survives
concerning the payments for these manuscripts and the present miniature is
documented in 1473: *Uno minio grande de la Risurrexione con storie per ducati vinti, lire
112.*

 Girolamo was first heard of in 1461 in connection with the illumination of a
Missal for Barbara of Brandenburg, Marchesa of Mantua, for which Andrea
Mantegna was to arrange the terms. The influence of Mantegna is clearly seen here
in the figure style and the landscape. Christ is shown rising from the tomb with the
soldiers below and in the distance the two Marys. It is early morning, and a crescent
moon shines above with the sun rising on the horizon. This scene is framed by the
initial *R* painted mainly in gold with jeweled clasps. The letter has been given
three-dimensionality, and the upright is a fluted column. It is set on a blue ground
and the classicizing leaf scroll extends to the right into the text, and above and
below it merges with the scroll of the border. Four roundels framed with wreaths
contain other scenes after the Resurrection, including the *Noli me Tangere*. These
have the appearance of portholes opening from the page to distant landscapes
behind. At the same time, Girolamo painted close-up details in *trompe l'oeil* such as
the pearls and the glittering jewels with their gold settings. Thus three levels are
suggested, the page itself, with script and music acting as a dividing layer. Resting
on it and seen as if close to us are the letter and the ornament, while behind it we
can look through beyond to an imaginary view. It is interesting to compare a
Gothic representation of the same scene in the same context in the *Beaupré
Antiphonal* and to contrast Gothic with Renaissance spatial organization (Plate
33).

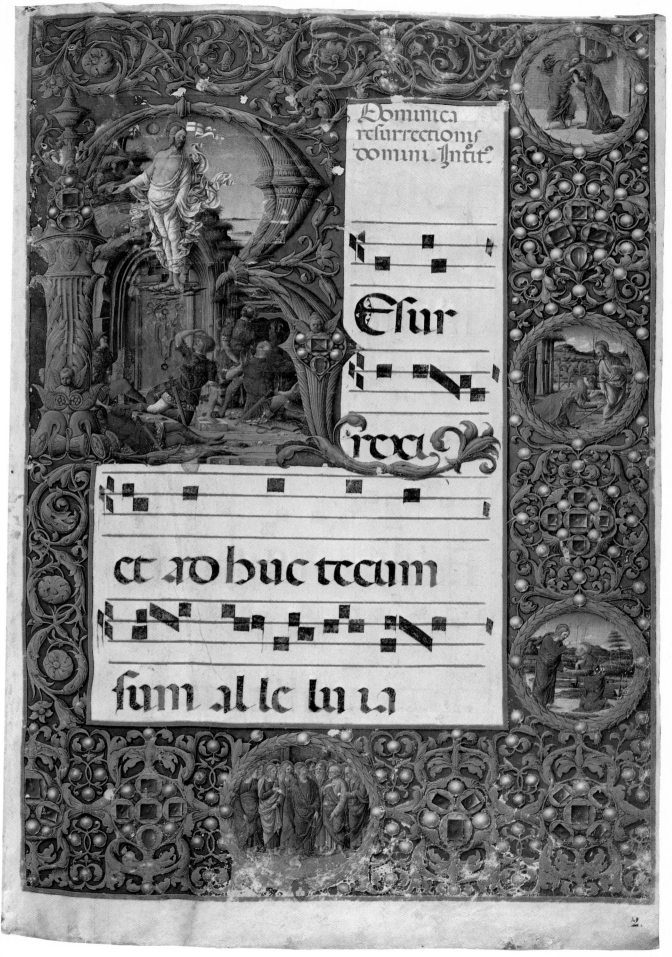

Dominica
resurrecionis
domini. Introit.

Esur
rexi

et adhuc tecum

sum alleluia

PLATE 40

Jean Miélot, Miroir de la Salvation Humaine
fol. 1 M.

This initial introduces a French verse translation of the *Speculum Humanae Salvationis*, an earlier devotional work, made by Jean Miélot. The translation was intended for Philip the Good, Duke of Burgundy, and this copy—which bears notes that it was written at Lille (of which Miélot was a native), at Brussels, and at Bruges in 1448–49—was a draft version of the text which was copied later in more luxurious versions. Author, scribe, and miniaturist, Miélot was at that time attached as secretary to the Duke's court and evidently was moving about with it.

The manuscript contains several large decorated initials similar to the M shown on this page. On folio 2 a D is accompanied by Miélot's device: *Savoir vault mieulx que avoir,* "To know is better than to own," a suitable motto for an academic author! This page also bears a note: *hystorie, cadele et escript de ma main l'an 1448.* From this we can be sure that Miélot wrote the manuscript himself, and also executed the miniatures as well as the initials. We know from other sources that the interlaced pen flourishes seen in these initials were called *cadeaux* in French and *cadels* in English.

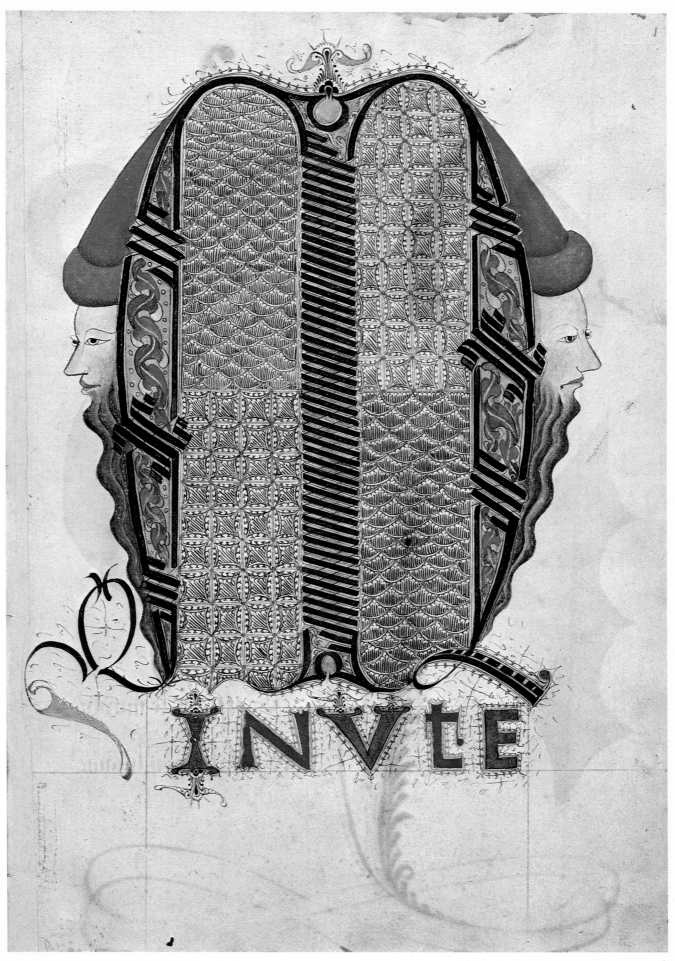